DIGITAL
CLOSE-UP
PHOTOGRAPHY
Q&A

GREAT TIPS AND HINTS FROM A TOP PRO

PAUL HARCOURT DAVIES

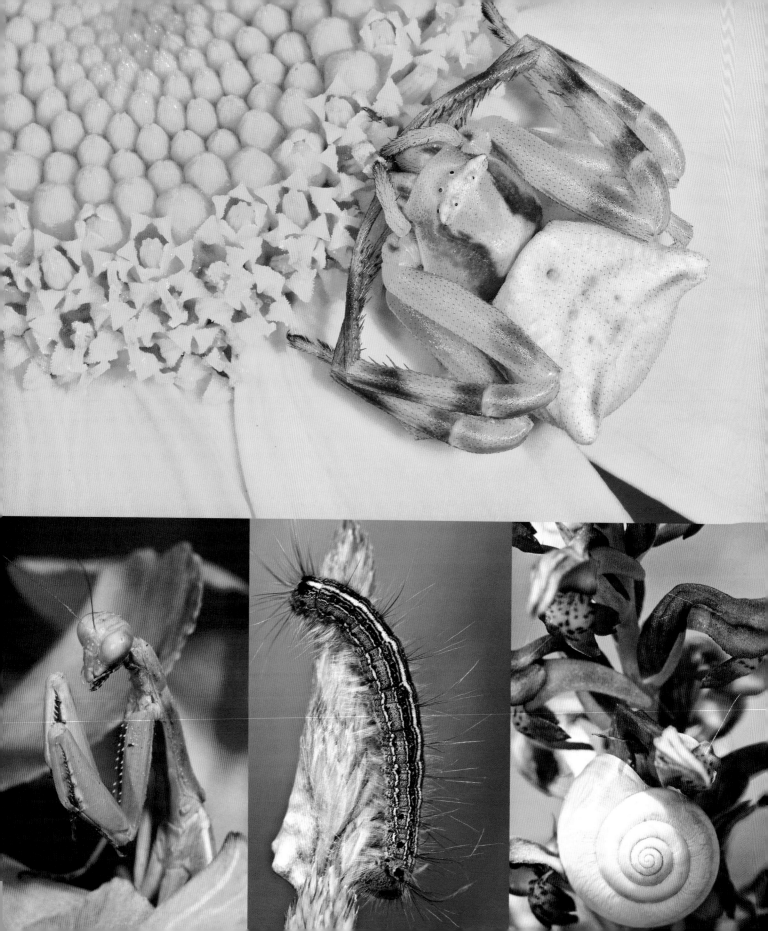

DIGITAL
CLOSE-UP
PHOTOGRAPHY
Q&A

GREAT TIPS AND HINTS FROM A TOP PRO

PAUL HARCOURT DAVIES

An Imprint of Sterling Publishing Co., Inc.
New York

Art Director: Ginger Graziano
Cover Designer: Thom Gaines
Production Coordinator: Lance Wille
Drawing Illustrator: Sandy Knight

10 9 8 7 6 5 4 3 2 1
First Edition

Published by Pixiq, A Division of
Sterling Publishing Co., Inc.
387 Park Avenue South, New York, N.Y. 10016

Distributed in Canada by Sterling Publishing,
c/o Canadian Manda Group, 165 Dufferin Street
Toronto, Ontario, Canada M6K 3H6

Distributed in the United Kingdom by GMC Distribution Services,
Castle Place, 166 High Street, Lewes, East Sussex, England BN7 1XU

Distributed in Australia by Capricorn Link (Australia) Pty Ltd.,
P.O. Box 704, Windsor, NSW 2756 Australia

If you have questions or comments about this book, please contact:
Pixiq, 67 Broadway, Asheville, NC 28801
(828) 253-0467

Manufactured in China

ISBN 13: 978-1-60059-899-9

For information about custom editions, special sales, premium and corporate purchases, please contact Sterling Special Sales Department at 800-805-5489 or specialsales@sterlingpub.com. For information about desk and examination copies available to college and university professors, requests must be submitted to academic@larkbooks.com. Our complete policy can be found at www.larkcrafts.com.

Dedication

To Tallulah, Orlaith and Kaya—guardians of the future: May you never cease to find fascination in the world around you, and treasure it . . .

Acknowledgements

Living on a hillside in Italy, I depend on the Internet for contact with numerous friends worldwide who share my twin passions for nature and photography.

My particular thanks for shared experiences, stimuli, and ideas go to fellow *Images from the Edge* bloggers Niall Benvie and Clay Bolt; for inspiration over the years to Peter Parks and Robert Mash; and to my children Hannah and Rhodri, who encourage their eccentric dad. In Italy are the kindred spirits of Pierluigi Pacetti, Pino Ratini, and Leonardo Battista, who generously share the special places in their country with me.

At Pixiq, with Marti Saltzman and Kevin Kopp, and with designer Ginger Graziano, I have been privileged to work with a team whose determination matches mine: I am more grateful than you know.

Last, but far from least, my thanks to my soul mate, Lois Ferguson, whose encouragement and positive criticism, and especially her ability to make me recognize the absurd in both myself and in the world around, makes a huge difference.

Table of Contents

Foreword

The world at close-quarters has the unique capacity to bring out the inner child in all of us, and offers endless fascination close to home. The arrival of the single-len-reflex (SLR) camera created a revolution with its capability to view exactly what would appear on film. Digital photography allows a great leap forward, offering accessibility to all by opening amazing possibilities, even with modest cameras.

This book guides you into a world you never thought possible; it shows what you can achieve when you take charge of your camera. Here, within a question-and-answer format, is something different, where the basics are provided for new photographers in an easily understandable way that never patronizes, where no established techniques are sacred, and where anyone interested can travel much further at their own pace. Experienced photographers will find numerous ideas to expand their creative palette, such as using image stacking, wide-angle close-ups, and much more.

The intention of this book is to empower you to create stunning close-up and macro photographs—and not just of flowers, insects, or leaves—but to recognize opportunities everywhere in the patterns and details found in the world that surrounds us all. This is a universe that fascinates me, and my hope is to act as a facilitator and help anyone get pleasure from this world that gives so much to me, and to encourage them to make their own forays and discoveries. It is great to be able to share in this way with fellow photographers.

With the immediate feedback a digital camera affords, it is easy to fine-tune exposure and composition to produce pictures that many would not have believed possible in the day of film. And you are not restricted to still images, for camera software makes time-lapse easily possible, allowing you to create your own film of a flower opening or a butterfly emerging from a chrysalis, for example. HD video is a fantastic tool that is now included on many digital cameras.

This book takes you through all the steps needed to get great close-up and macro photographs, from modest levels of enlargements to several times life-size. There are numerous hints on equipment (including building your own rigs), advice on eye-catching compositions, examination of techniques to exploit limited depth of field, and a study of workflow for optimizing results during post-processing. All this and much more—now all you need is your imagination and the motivation to get out there with your camera.

Paul Harcourt Davies

Close-up and Macro Basics

Perhaps you've been honing your skills and producing some nice pictures, and now you find yourself ready to expand into new photographic realms. You've seen dramatic close-up shots and understandably want to take your own—now's the time for a new challenge. Well, that is the reason for this book—to introduce and sustain an interest in an area of photography that you will no doubt find as fascinating as I do, and to help you discover and record subjects in ways that deliver new insights into the world that surrounds us and largely goes unnoticed.

In this first section we ask questions and provide information about the basic elements that formulate the foundation for close-up and macro photography. I trust that this section, as well as this book in its entirety, will provide a thorough grounding to help you understand how to shoot excellent close-up and macro photos, and serve as a resource that you can come back to time and again.

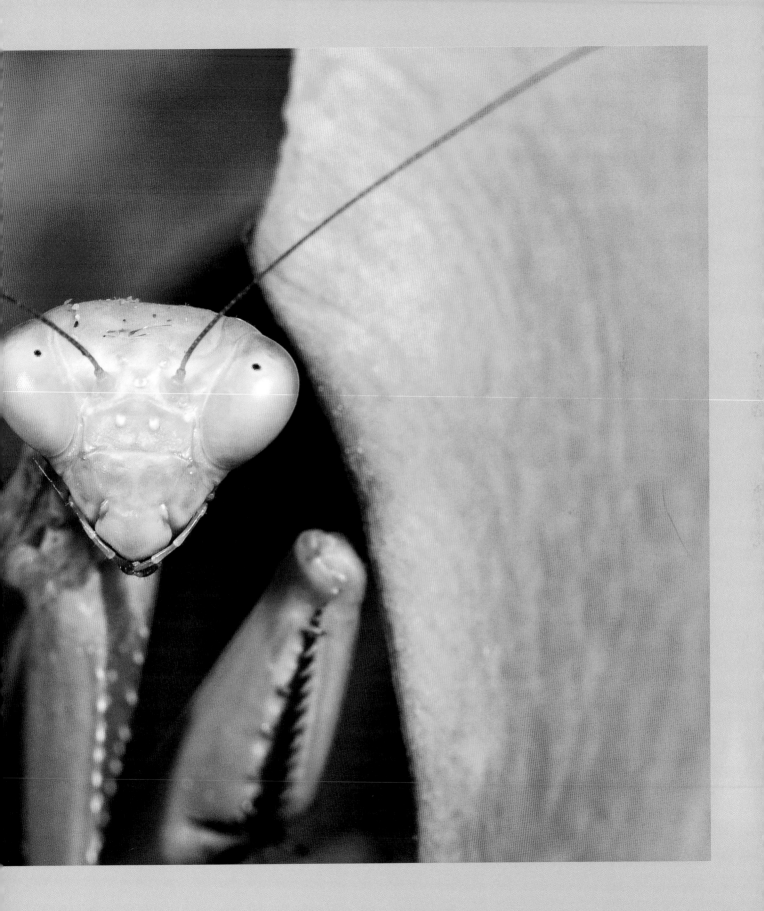

What's the difference between close-up photography and macro photography?

Newcomers to this field often find the language confusing because terminology is not always used consistently. Manufacturers began to use the prefix macro as a selling point for what were, in fact, their close-focusing lenses . . . but macro sounds better in a sales pitch. Well, no matter, let's take a look at the jargon.

Though the terms close-up and macro are often used interchangeably, they refer to separate ranges of image sizes as measured on the sensor. The terms **magnification** and **reproduction ratio** are both ways to quantify how big an image on the sensor is compared to the subject being photographed.

For example, if the reproduction of a subject on the sensor is exactly the same size as the real-life subject, the magnification is known as 1x, while the reproduction ratio would be 1:1. Therefore, **life size** means a subject (or the part of it you are photographing) is the same size as its image that is focused on the sensor. If an image on the sensor is one-half the subject's size, the magnification is 0.5x, and the reproduction ratio is 0.5:1. On the other hand, if the image on the sensor is twice the actual life size of the subject, the magnification is then 2x, and the reproduction ratio is 2:1.

A **macro lens** of whatever focal length is a highly corrected lens that has been designed to give its best performance when used close to a subject. It is usually a prime lens that can reproduce an object at life size as its highest magnification without accessories. However, in practice, you can increase this magnification up to about 5x (the realistic upper limit in the field) by using the photomacrography accessories mentioned below. Some zoom lenses have a Macro setting, but that is really just a close-focus tool.

Close-up photography is a term used by most photographers as more of a general description than macro. Its range of magnification begins at 0.1x, meaning the image on the sensor is one-tenth life size. Close-up's application extends to 1x.

Macro photography, sometimes just called macro, refers to a magnification range from life size on the sensor to about 20 times life size, though it is most often used by photographers to describe images in the range of 1x – 5x.

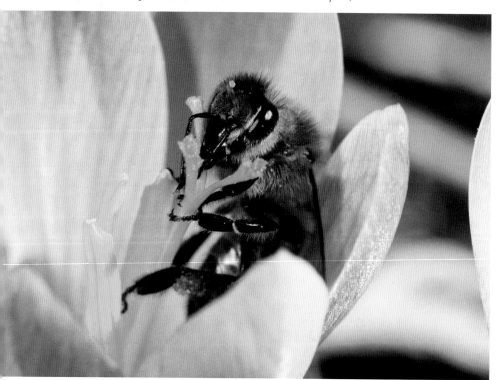

A single bee is captured at life size on the sensor—in the strict sense this is a macro shot.

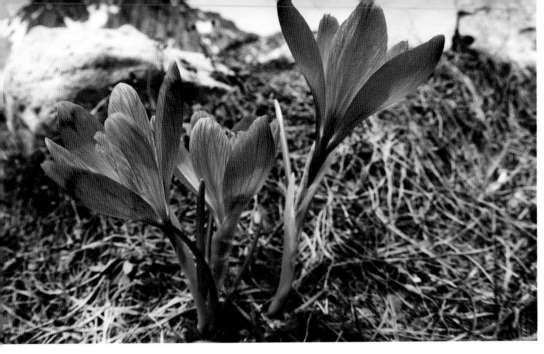

These crocus flowers are not life size on the sensor, but they are close-up. Taken from a short distance away with a wide-angle lens in a mountain landscape, they dominate the foreground.

As a catchall phrase, close-up photography encompasses the use of zoom lenses, wide angles, and even macro lenses. Throughout this book I'll use it and I'll use macro to refer to magnification that starts at 1x. However, practically speaking there has always been considerable overlap, and many have given up to just use the term macro for everything.

True macro is a term used to embrace a range of macro photography that uses equipment, such as bellows and special lenses (see page xxx), perhaps in a studio or lab, to reproduce images at ratios greater than 5:1, up to about 20:1.

Photomacrography is often used as a synonym for macro photography, but technically its specifications lie beyond the limits of the 1:1 ratio of so-called macro lenses, which can be achieved by using extension tubes, teleconverters, bellows, and special purpose lenses designed for magnifications up to 20x.

Photomicrography starts where macro ends (greater than 20x), and it becomes appropriate to use a microscope. In practical terms, there is overlap between photomacrography and photomicrography.

Macrophotography is nothing more than an improper way to write macro photography since it means the photography of very large objects on a large scale.

Microphotography may be thought of as the opposite of macro photography, involving the reduction of images optically to very small sizes, as with the printing of circuits onto microchips or microfiche.

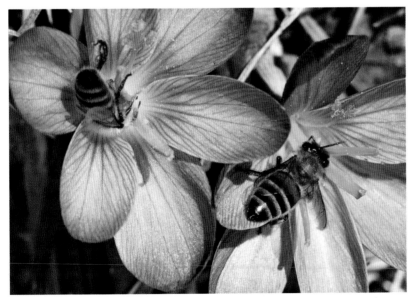

Moving in closer on the crocuses captures a close-up of two bees at work pollinating the flowers.

Q How are digital images made?

A Fundamentally, any camera, whether digital or film, comprises a light-tight box with a lens at one end and a light-sensitive medium (a sensor or film) at the other. The lens collects and focuses light to form an image on the medium. In film cameras, light triggers a reaction with chemicals embedded in the film; while in digital cameras, the light strikes an array of photosites arranged on the sensor. Each photosite is like a tiny light meter that then generates an electric current, the magnitude of which depends on the brightness (intensity) of the light.

The Bayer array shows two green-sensitive photosites for each blue and red site, matching the sensitivity of human vision.

The red filter on a photosite blocks all colors of light except red, while the green filter blocks all but green light and the blue filters all but blue light rays.

A sensor's photosites are sensitive only to the intensity of the light that strikes them. To produce color, each site is equipped with a red, green, or blue filter that causes it to respond to just that primary color. Because the human eye is more sensitive to green than to the other colors, these filters form a regular alternating pattern (Bayer array) over the sensor with two greens for each red or blue. The electrical impulse from a photosite is digitized and, by comparing the pulse strengths from neighboring sites, the camera's electronics system generates an appropriately colored pixel through the process of interpolation. Together, these pixels from each photosite make up the final image file.

You can use any digital camera for close-up photography, though you will probably need an additional lens to enter the macro range. In addition to their general adaptability to different photographic conditions, one advantage of DSLRs is the lack of delay often found in point-and-shoots between the time you press the shutter and the time the image actually records. This is known as shutter lag, and can hamper your efforts to shoot living insects or other creatures that are likely to move during the lag time.

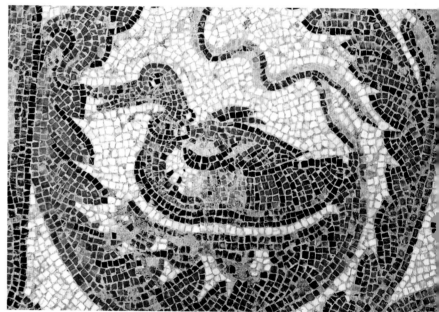

A Roman mosaic from Sicily creates the picture of an animal from pebble-sized tesserae, the bits from which the mosaic is made up. This is not unlike the way a digital image is formed from pixels.

What is meant by crop factor?

Before the introduction of digital cameras, photographers naturally became accustomed to the way their lenses recorded images on a 35mm film frame (36 x 24mm). It was therefore a bit confusing when sensors came out that were smaller than the frame size of 35mm film. This meant that only a portion of the image produced by their old film SLR lenses would be reproduced on the sensor. In effect, the image was cropped, and the lens' angle of view on the digital camera was narrower, taking in only the central portion of the image.

So it made sense to choose the familiar 35mm film system as a reference standard for digital cameras to compare angles of view between the sensor-based technology and film-based photography. Eventually, sensors did emerge that were the same size as a film frame; these are referred to as full-frame, or FX. But smaller sensors are still more common (e.g. APS-C, Four-Thirds). A crop factor of 1.5 means that the focal length used to capture a digital image must be multiplied by 1.5 to have the same angle of view as that image captured on 35mm film (or an FX sensor). So a 300mm focal length on a digital camera is used to record an image with an angle of view equivalent to that of a 450mm focal length on film (1.5 x 300 = 450). This crop factor varies depending on the size of the sensor being used, leading to different cameras having different crop factors. This is still true, unless you happen to use a FX sensor.

Consequently, a mistaken idea is sometimes propagated within photography (particularly when dealing with macro and with telephoto lenses) where a crop factor of 1.5 is confused with a magnification of 1.5. Don't fall into this trap—these are two different concepts. A macro lens boasting 1.5x magnification

This image illustrates the image area of a full-sized sensor (FX) and the central crop that would be recorded by an APS-C sensor.

This is the APS-C crop as it would look on a full-sized sensor. To capture this angle of view, the FX sensor would require a longer focal length than that used to record the top photo.

gives exactly that scale of reproduction on the camera sensor, no matter what the sensor size, though a smaller sensor will have less total area surrounding the magnified subject.

How many megapixels do I need?

A pixel is the smallest element of brightness/color that contributes to a digital picture. A megapixel (MP) is one million of these. When used in reference to a sensor, a pixel describes a single photosite. This means that a 14-megapixel camera has a sensor with 14 million light sensitive sites, though not all of these will be used to generate an image file since some are utilized for other purposes, such as generating data about the image.

of blocks. In a relatively short period of time, however, technology has advanced and now it is difficult to find even a point-and-shoot camera with less than 10MP, and even those in mobile phones have at least 5 – 6 million pixels. (Mobile phones can generate astonishingly good images and are great for impromptu shots.)

Camera manufacturers have encouraged the pixel race because people everywhere buy into the idea that the more pixels the better. Over the course of a mere decade, the typical megapixel count for digital cameras has risen from two or three to six or eight to 10 or 12, and even to 16, 18 and beyond.

Yet let's consider if more is always better. The size of an image file (in megabytes) is related to the number of pixels used to record it—more pixels mean bigger files. In theory, more photosites (a higher pixel count) should also mean sharper pictures because you are recording more detail. This is important in close-up and macro photography where very often a primary goal is to capture as much detail as possible for your viewer to discern. However, squashing more and more of these photosites onto the given "real estate" of a sensor means there are limits when it comes to picture quality. For example, it is quite possible for a camera with a physically small sensor to have the same number of photosites as one with a full-frame sensor. But in that case, the individual photosites on the bigger sensor will be larger and the random noise (always present and generated by natural thermal motion of electrons in the sensor) will be a much smaller proportion of the output from that site. The resulting image will appear cleaner, i.e. it will be sharper with better color and free of noise in the shadow areas.

A major part of the appeal behind a macro image is to distinguish as much detail as possible. This bug was recorded with a 14-megapixel sensor, which is more than ample for large prints with plenty of sharp detail.

The first digital cameras on the market over two decades ago had fewer than 100,000 pixels (0.1MP), and their images looked distinctly jagged, as if they were made

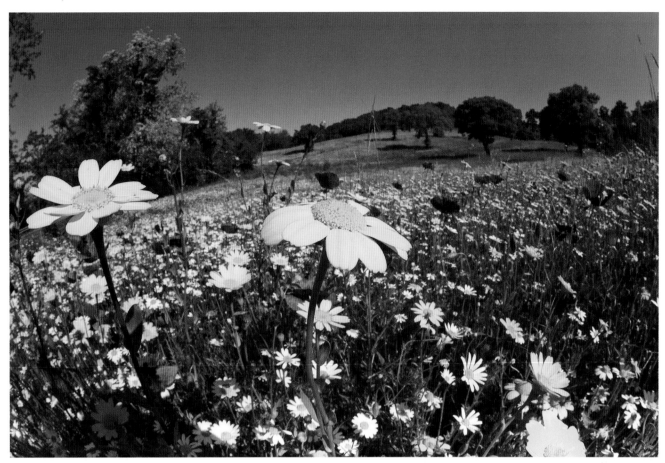

One of my cameras records a RAW file that produces an image with 4288 x 2848 "effective" pixels—the pixels that actually generate the picture. This calculates to 12.2MP (4288 x 2848), and it produces a file of 13.34 megabytes (MB). I have found that 240 ppi (pixels per inch) is perfectly adequate for making high-quality prints for exhibition. That means this file will produce prints of 17.9 inches (4288/240) by 11.9 inches (2848/240); which in metric would be 45 x 30 cm. In fact, I could upscale this image to an even bigger size by using a specialty program, such as Genuine Fractals, without experiencing noticeable degradation in detail or image quality. Consequently, a 12-megapixel array is more than enough to produce excellent exhibition quality prints at large sizes.

The larger the count in megapixels that a camera boasts, the larger the prints you can make and the finer the level of detail in complex scenes such as this field of wildflowers.

This image from a series has been made into a print that is several feet tall using the upscaling that a program like Genuine Fractal affords—a nice capability if you ever need it.

What kind of camera is best for close-up and macro work?

Though you want a camera that is not limiting for your macro adventures, you can master much of the technique involved while using a variety of camera types, from high-end DLSRs to much less sophisticated models to compacts and even camera phones. Interesting close-up images are actually the result to two things: (1) Discovering good subjects and (2) the way you see or interpret the subjects.

For framing and focusing, you need to be able to see what you are doing. Such capability is what made SLR cameras revolutionary in macro, and why DSLRs are still your best equipment choice. A camera with an optical viewfinder lets you focus critically, and live view technology displayed on larger LCD screens is continually improving. Though framing is more difficult with compact cameras and camera phones, a number of photographers are experimenting with the use of a magnifying glass or even a jeweler's eye loupe to get close enough to enter the macro realm.

What is probably just as important as the type of camera is the sensor being used, and there are several to choose from.

So what are the benefits or drawbacks of different sensor formats? In part, this depends on how big you want to print or display your images. Larger sensor sizes quite often allow for larger prints and provide finer details

	FORMAT/ SIZE (mm)	TYPE: BRAND
Full frame (FX)	36 x 24	DSLR: any brand
APS-C (DX)	23.6 x 15.6	DSLR: Nikon, Pentax, Sony
APS-C	22.3 x 14.9	DSLR: Canon
Four Thirds	17.3 x 13	DSLR/Mirrorless: Olympus, Panasonic
1/1.7 inch	7.6 x 5.7	Compact
1/4 inch	3.2 x 2.4	Camera phones

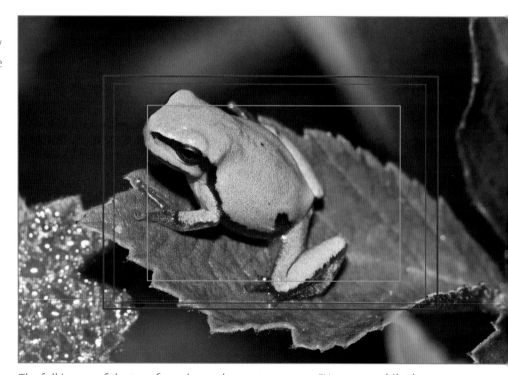

The full image of the tree frog shows the capture on an FX sensor, while the colored rectangles denote smaller sensor sizes: APS-C (DX) (red), APS-C (blue), and Four Thirds (orange).

with less noise, but they also cost more to purchase. And though larger sensors generally contain more megapixels, that is not always true. An APS-C and a 1/1.7 may both have 12 or 14 (or some other number) megapixels. But a larger sensor will have physically larger photosites (see page 14) than a smaller sensor with the same number of pixels. In theory this should mean lower random noise in shadow areas and a better low light performance. However, current versions of image-processing software can reduce noise to the extent where it is difficult to see the difference.

One feature that close-up/macro photographers like about APS-C sensors is their frame-filling capability, due to that format's crop factor (see page 15). Increasingly, enthusiasts realize that you can get great results with lighter, less expensive cameras that boast sensors smaller than FX.

Finally, the higher the magnification provided by a lens, the shallower the depth of field (see page 22). When comparing APS-C to FX formats, you need a lesser degree of magnification to produce the same sized image, which results in a greater apparent depth of field. This can be an advantage in terms of perceived image sharpness. Though images captured on small sensors may reveal more artifacts and imperfections as they are enlarged, it is the difference in depth of field that is usually more noticeable than any difference in image-quality when comparing an APS-C or Four Thirds sensor to a full frame one.

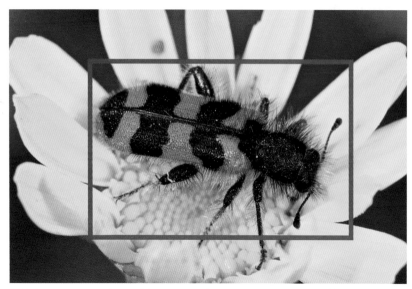

This image was taken with a macro lens set at a 1:1 reproduction ratio (see page 12). The red rectangle illustrates the image if recorded with the same lens on an APS-C sensor with a crop factor of 1.5.

To get the same shot as the full-sized image above, you would use the macro lens set at a 2:3 reproduction ratio to take the crop factor into account. This photo appears to have greater depth of field because it is recorded at a lower magnification.

Q Which file format should I choose?

A Digital images can be recorded by cameras and stored in several different file formats, but the two most popular are JPEG and RAW, though TIFF is also widely used.

JPEG is the most popular and probably the best known of all image files because it is universally readable by all types of computer systems. This format is easy to send in a variety of ways over the Internet and to display on websites and social networking sites. While JPEG files are capable of displaying the 16.7 million colors that are

This is a page from my blog on Pixiq. Large files are not needed if you want to post images on a website or Facebook. JPEGS are ideal because they can be compressed and downsized in nearly any image-processing program.

needed for photorealistic pictures, many cameras allow you to set different pixel quantities (small, medium, and large resolutions) within the JPEG recording option, as well as a variety of compression levels. In fact, JPEG is actually a compression standard, so redundant data is eliminated, meaning these files are smaller than RAW files. Your camera will usually process JPEGs according to its particular programming.

If you open JPEGs in an imaging program and make additional enhancements, the file will discard data every time you resave it. This is no problem if the file is large and you only do so a few times, but small files will rapidly deteriorate if alterations and resaving are repeated. It is therefore a good idea to save your original JPEGs and enhance only duplicates.

RAW format tends to be found on cameras that are more sophisticated than basic point-and-shoot models. The 14-bit files are large and require substantial memory because they include all the unprocessed data from the sensor without compression. Each camera manufacturer produces a proprietary version of RAW and usually issues their own software to deal with reading the RAW files and making adjustments and output. A number of software companies also make programs to deal with RAW files. In particular, Adobe has created a RAW plug-in that works with Photoshop, Photoshop Elements, and Lightroom to read all the different RAW versions from the different camera manufacturers. They have also invented a universal RAW format—DNG (Digital Negative). From my personal experience DNG is excellent.

TIFF format can also handle 16.7 million colors, and any compression is lossless, so a TIFF file is much bigger than a JPEG that stores the same data. They also will not deteriorate due to compression as alterations are made and resaved over time. Because of this quality, TIFFs

are often used for print files, and agencies usually request that photographers supply TIFFs. In practice, high-resolution JPEGs are equally good.

It is important to anticipate how you plan to use your images in order to determine which format suits your photography best. There is incredible macro work being done where photographers have recorded JPEGs at high resolution and best quality (low compression level), a camera setting that allows everything from large prints to thumbnails. If you simply want images for web display, small JPEGs will take up less memory on your card or hard drive and take much less time to upload and view. Large files take up valuable memory space, but you can always reduce them if needed using software. However, enlarging small photo files often results in softer, less detailed images.

A macro shot with stunning sharpness and color is a wonderful photo no matter what recording format you use. However, my choice is RAW because I want as much control as possible over the final image. Working with RAW files in Photoshop, Lightroom, and other RAW conversion programs offers the widest latitude during image processing to adjust color, exposure, and contrast. There is also an astonishing ability to pull some over/underexposed shots back from the brink of uselessness to an extent that film never permitted.

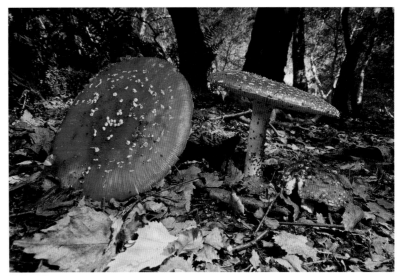

These attractive—but poisonous—mushrooms (Amanita muscaria) are rendered from a RAW recording. You can discern every detail of the forest floor and background when the image is displayed at 100% on a computer screen (where each pixel of the original file is a screen pixel).

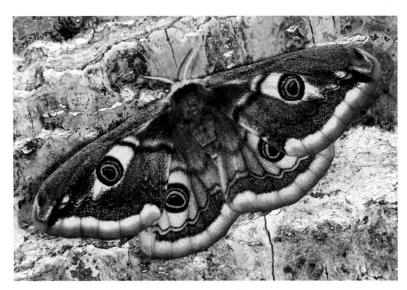

The wings of this female emperor moth (Saturnia pavoniella) reveal quite an extraordinary level of detail with subtle tones. RAW processing programs offer excellent enhancement tools and the RAW format ensures that much more data are captured by the sensor than when using JPEG format.

Why is depth of field important?

Depth of field (DOF) refers to an area within a scene that extends from the distance in front of and behind the point of sharpest focus where details still appear sharp. It becomes particularly important in close-up and macro imaging because this distance decreases dramatically, sometimes down to fractions

diffract—spread out—and that results in a softening of the image (see page 25). Though depth of field can be increased (when magnification is kept constant) by stopping down the lens, magnification is a more important control than focal length over depth of field in macro photography. For example, at life-size, macro lenses of focal lengths 50mm, 100mm, and 200mm give exactly the same depth of field at the same aperture. And the same thing happens at any other stated magnification.

Note: See the table in the appendix (page 142).

Image stacking is a wonderful technique to create extraordinary photos with increased depth of field (see page 88). Just remember that in maximizing depth of field, it is often important to sharpen your results, but shallow depths of field can also produce beautiful images while offering a creative approach to recording common subjects.

The raindrops on the leaves of the Ginkgo suggested the use of a shallow depth of field to capture the mood, which becomes far gentler with a soft green background than a very sharp, contrasty background.

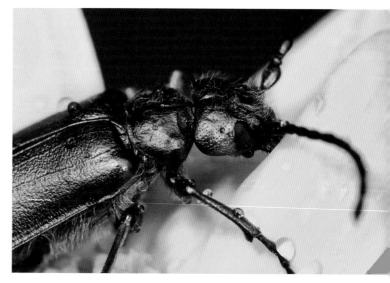

Every bit of depth of field was needed to record each hair and eye facet of this flower beetle.

of a millimeter, as you produce images of greater magnification on a sensor. This is significant because you might not get as much of your subject as you want within the narrow field of sharpness.

It might seem a given to use smaller apertures to generate maximum depth of field. But when light passes through very small openings, its waves tend to

What on earth is bokeh?

Bokeh is a Japanese word that describes the character of the out-of-focus background produced by a lens in a photo. The idea is important when using large apertures where the depth of field will inevitably be shallow and large areas of the photo may be out of focus. In close-up and macro photography, long telephotos and macro lenses are often used this way for artistic effect.

A pleasant, soft bokeh adds to the attractiveness of a picture without distracting from the subject, and is usually dependent upon on the type of lens used. Whereas a wide-angle lens will render the foreground and/or subject sharp while also retaining detail in the background, telephoto lenses tend to isolate subjects from their surroundings. The factors affecting bokeh include:

- The focal length of the lens (the longer this is the more blurred the background).

- The size and shape of the aperture (the wider this is the more blurred the background).

- How well the lens is corrected for spherical aberration.

The sharp parts of an image can be thought of as points, but away from these—in the out-of-focus areas—the light spreads slightly (diffracts) and the points become less defined, like small discs that can be referred to as circles of confusion. These areas comprise diffraction patterns in which the edges assume the shape of the aperture as formed by moveable blades in the iris diaphragm (the lens structure that contains the aperture). If the aperture is perfectly round, then overlapping images blend harmoniously and backgrounds look soft and smooth, producing what is

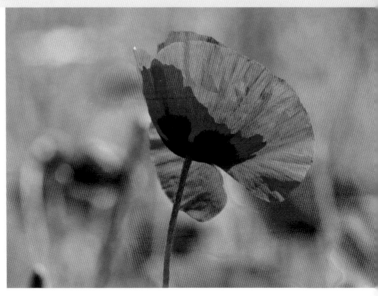

The gentle softness of the background becomes a series of soft blurs—the red of poppies and blues of corn-flowers. The quality of this bokeh helps the single backlit poppy to stand out as the subject of this close-up.

judged to be good bokeh. If, however, the diaphragm consists of a series of angled lines like a pentagon or hexagon, the angular edges result in bokeh that is deemed harsher and less pleasing. The number of blades in a lens' diaphragm influences the degree of roundness, so that more blades result in a more perfect circular opening. In addition, it is also better if the blades are slightly curved.

Bokeh is also affected by whether these circles of confusion are uniformly illuminated—they can be brighter at their center than at their edge, and vice-versa. There can also be a difference in the brightness of the discs behind and in front of the plane of focus. Such brightness factors depend on how effectively the lens can control spherical aberration.

What's the difference between resolution and sharpness?

Two imaging concepts that often get confused in the digital photography realm are resolution and sharpness. Let's try to quickly sort through that confusion.

Resolution is the ability of any lens system (including our eyes) to separate two objects (e.g. points or lines) that are very close together. The higher the resolving power of a lens, the better it can separate such details clearly. However, no matter how high the resolving power of your lens, you also have to keep in mind the camera's sensor. Factors that affect what you actually see in the image include the size of the camera's photosites, the pattern in which they are arranged, and their distance from each other.

Note: To make matters even more muddied, the idea behind resolution stated above in term of lens systems is different than the use of the term to signify the quantity of pixels on a sensor or in a digital image.

Sharpness depends on the viewer and is much more subjective. The perception of sharpness depends on several things:

- How the lens separates fine details (its resolving power).

- How the lens copes with changes from light to dark from one shade of color to another, particularly at boundaries between objects (contrast).

- How you view the image. Whether an image appears sharp or not can depend on illumination and how far away you are from it.

Many who view pictures on computer screens often expect far too much from an image in terms of sharpness. They typically sit too close, often less than 12 inches away (30 cm), while checking images at 100% of their size. When viewing an image at 100%, each pixel in the file is represented by a pixel on the computer screen. A file with a width of 4200 pixels and screen resolution of 72 pixels per inch would be 58 inches (1.48 meters) wide. If that picture were on the wall, a person would want to stand much farther back to look at it. In fact, to maintain a comfortable viewing angle of 60° along the diagonal, a person would stand over 4 feet (1.27m) away. When we are too close, our eyes will resolve the individual pixels and the picture will not look as sharp as possible. In reality, we are probably spoiled by the quality of the photographic imaging equipment we have available to us.

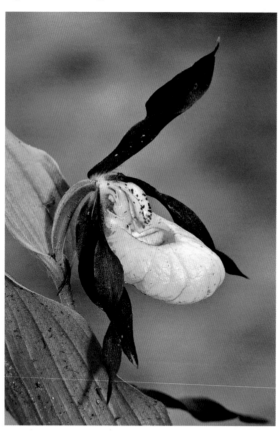

The rare and elusive lady's slipper orchid is sharp in every detail, but its separation in distance from the blurred stream behind accentuates the perception even more intensely.

Why do images look softer when small apertures rather than larger ones are used?

Photography beginners soon learn that the diameter of the lens diaphragm is related to the f/number, and that a large f/number represents a small aperture (and vice versa). As the setting on the camera moves from one f/number to the next, the area of the aperture changes by a factor of two: it either doubles or halves, depending if you change the f/number up or down.

Closing the aperture (stopping down) produces greater depth of field in the photo, but this comes with a cost. Diffraction, an inescapable property of light waves, becomes obvious at small apertures (such as f/16, f/22, and f/32) and creates a definite softening of edges so that details are blurred. That's because wavefronts from light are affected by the perimeter of the aperture as they pass through the lens, tending to spread. Diffraction always affects light passing through an aperture, but it is much more noticeable at high f/numbers than at low ones because the proportion of the wavefront affected is higher due to the reduced aperture size.

If, for example, you move in close to take shots of an insect's eyes, the temptation is to stop down, increasing depth of field to get as much of the eye in focus as you can. Consequently, if you took two shots at f/8 and f/32, you'd find four times more depth of field at f/32. But looking carefully at the sharp details on both, you'd see that the edges at f/32 are less well defined (i.e., soft). The balance between sharpness and increased depth of field is a difficult one to achieve—one technique that helps in a number of cases is to use stacked images (see page 88).

With today's sophisticated image-processing programs, such image softening can be ameliorated. The diffraction process is not reversed, but the appearance sharpens as a program's algorithms alter the tone of pixels at edges and color boundaries.

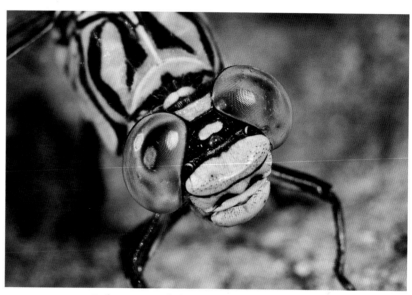

Software can help solve the dilemma that occurs when the edges that form a dragonfly's compound eye become less well defined due to the refraction that results when the lens is stopped down.

The Sweet Spot

All lenses have an optimal aperture where an image will be sharper than at other apertures, and this sweet spot is typically between f/5.6 and f/11. The difference in sharpness between this "sweet spot" and other apertures is most noticeable with zoom lenses at their extreme ends of the focal range.

Which metering mode should I use?

It is very easy to get sloppy about exposure when modern cameras and image-processing programs do so much of the work for us. However, when you take charge and get exposure "spot on," your image file will be as good as you can make it in terms of the information it has recorded.

Metering systems built into digital cameras read the light level in a scene and assess the combination of shutter speed and aperture required to get the correct exposure, which is based on the 18% reflectance of a standard photographic gray card. This works well provided nothing in the scene is very light (bright snow) or very dark (the proverbial black cat in a coal shed). However, it is asking a lot of any metering system when direct sun or reflections are in the scene; or if there are deep shadows and low light; or especially if there are both bright and dark. This is because existing conditions can mislead a camera's light meter. A white butterfly or a pure white lilly may lead the meter to determine that the scene on average is bright, therefore causing it to underexpose the resulting photo. Conversely, a photograph where a dark macro subject dominates may risk being recorded as overexposed because the metering system calculates a very dark average scene and overcompensates.

Camera designers have been truly ingenious in finding solutions to the problems of exposure. They have developed several sophisticated metering modes that offer the ability to provide a solution when the camera does not measure light equally from across the scene.

- **Spot:** The reading is measured from a small area in the scene, and the exposure is determined as though that spot was a midtone, regardless of the brightness values of the rest of the scene.

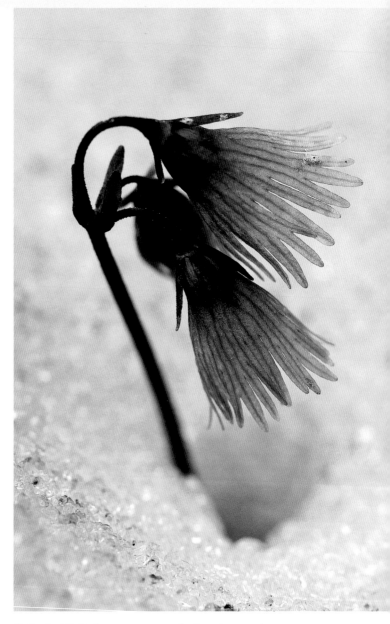

Reflected light from snow can fool meters and suggest that the overall scene is brighter than it actually is, causing the camera to compensate and underexpose. The properly exposed image above shows that snow is not always uniformly white, with detail in the crystal formations but also highlights from the icy snow.

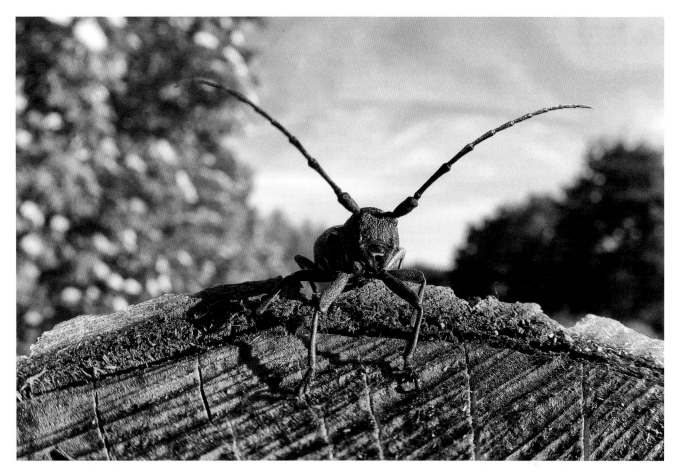

A dark beetle was photographed against the bright sky, with the spot meter set to get the foreground right and not lose detail in the insect's head region. The sky was then darkened slightly in Lightroom.

- **Center weighted:** The meter weights most of the reading from the center of the scene, often with the peripheral portion of the scene measured and included at a less-weighted value.

- **Matrix:** Sometimes called evaluative, this is the most reliable method in a great majority of situations. The viewfinder is divided into a number of different segments and the meter sensor reads light from each one. The readings are then compared with combinations programmed into the camera's memory.

The high-definition LCD screens found on recent digital cameras are like visual exposure meters where we can see just how well a camera has coped with a difficult scene involving extremes of light and dark. When reviewing your pictures, you can set the camera to blink on areas outside the acceptable range of highlight or shadow tones. A histogram is also very helpful in judging exposure because it objectively graphs the tonal range of your picture (see page 28).

Why should I try for the best exposure in-camera?

Programs like Adobe Photoshop and Lightroom allow us to rescue images that, in the days of film, would have been consigned to the trash bin. However, if you set your camera to record optimal exposure before bringing the image file into such programs, you will capture the maximum amount of detail to work with, particularly with regard to areas of brightness (highlights) and darkness (shadows). This will insure that you are able to get the best out of any post-production routine to create prints.

bright tones. If the graph sharply abuts either the left or right axes, tones at that end are clipped and will not show either shadow or highlight detail, respectively.

Digital cameras, other than the most basic, can produce a histogram. Many people ignore this display while making photographs, but the histogram is a tool that can really help optimize exposure. In close-up photography with wide-angle lenses, there can sometimes be a wide exposure difference between background and subject. This may make it impossible to select a metering mode that will cope. Here the histogram can indicate such conditions and lead you to

The Histogram

A histogram is a graph that shows the distribution of brightness levels in an image. Along the horizontal axis are 256 levels of brightness from pure black on the left side (0 value; shadows) to pure white (255 value; highlights) on the right side. The vertical axis represents a quantity that shows the proportion of pixels in each of the 256 values. A graph that is skewed heavily to the left describes a picture that has a lot of dark tones; a graph that is skewed to the right will illustrate a photo that has a lot of

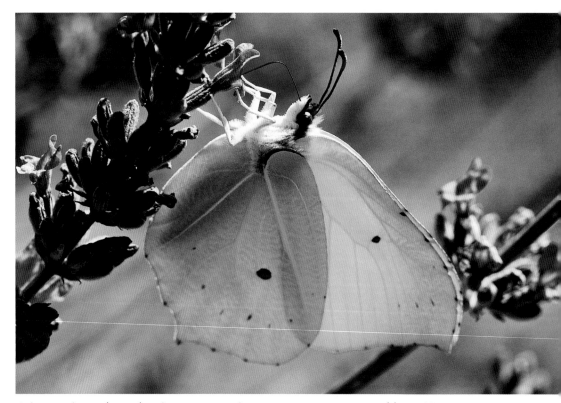

It is not wise to depend on image processing to correct exposure problems. Not only will your pictures display better quality if properly exposed in the camera, but you will spend less time at the computer and more time in the field actually recording close-up images.

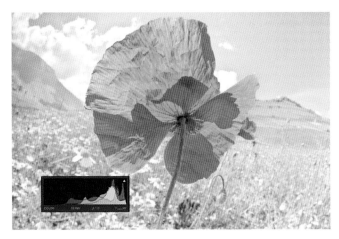

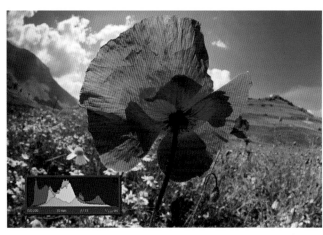

A histogram that is unbalanced to the right tells you that the image has recorded many more bright tones than dark ones. There will be highlight clipping when the graph butts against the right axis, evidence of overexposure.

An even distribution of tones from dark to mid to bright is documented when the histogram starts close to the left axis and ends very near the right axis. There is no clipping in this photo.

record an acceptable balance, allowing you to deduce whether fill flash or a reflector is needed to throw more light into the foreground.

Common advice to utilize a histogram is to "shoot to the right," which means to expose the image so the histogram will lean toward the lighter (right) side of the graph, coming as close to the right axis as possible without clipping. This will save you from losing digital information in the brightest portion of the picture, because once highlights are burned out (clipped), their digital information cannot be recovered.

Histograms in the camera, even for RAW recordings, are generated from downsized JPEGs, so they do not represent absolute exposure accuracy for a particular image. But they provide an excellent visual indicator and are of particular value when shooting in RAW format where the image file preserves the maximum amount of data and detail. You can ameliorate inevitable exposure errors such as blown highlights or loss of detail in shadows to record photos with as few artifacts as possible, making image enhancement go more smoothly.

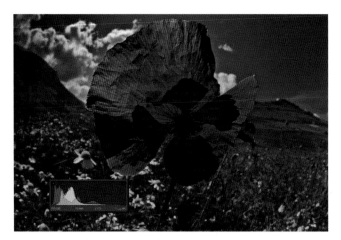

You can see that the tonal balance for this image is skewed toward dark tones. Unless your scene is dark to begin with and that is a mood you want to portray, this would be an indication of underexposure.

How do I use white balance?

ight is emitted when materials are heated. As the temperature rises, materials will glow red, then yellow, white, and finally bluish white: think of a log fire, an electric lamp, or the sun. This is because light has a different color according to the temperature of its source. The perceived color of the emitted light is measured on the Kelvin (K) scale, which is the basis of color temperature.

When you buy an electric lamp, you have a choice between a cool or a warm bulb. If you illuminate a perfectly white flower with each light, it will have a blue or yellow cast, respectively. Yet as you observe either situation, your brain tells you the flower is white in both cases.

Your digital camera, unlike your brain, does not interpret these color shifts; it merely records them. The white balance control (WB) on your digital camera is used to ensure that white objects in a scene look truly white, without a tint or cast. The WB function adjusts the camera's levels of blue and red sensitivity, depending on which light source you have set: Sunlight, Cloud, Shade, Flash, Incandescent, and Fluorescent. The Auto WB tells the camera to determine the setting, and it is surprisingly accurate most of the time.

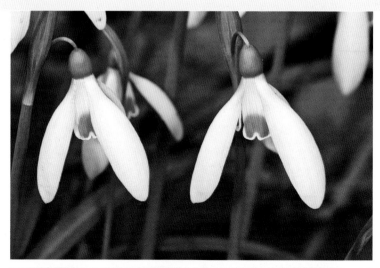

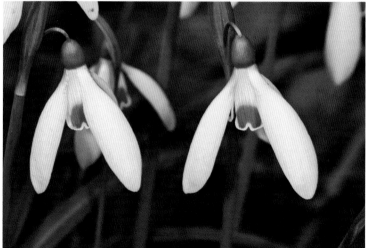

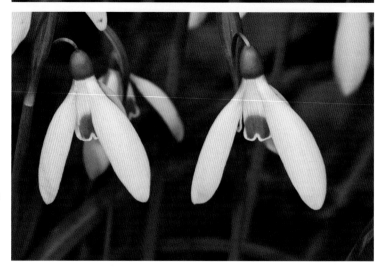

The differences are sometimes subtle, but the color casts of these three pictures of snowdrop flowers illustrates taking the same picture at white balance settings of Daylight (5500 degrees Kelvin), Cloudy (6500K) and Shade (7500K) from top to bottom respectively.

Many naturalists choose to record butterflies early morning and late afternoon—during the insects' periods of relative inactivity. Natural light just after sunrise or in the late afternoon is much redder and golden than it is at noon. The light is much cooler and bluer before sunrise. So you should remember to set your WB accordingly. However, one of the nice things about recording RAW files is the chance to very precisely adjust this color temperature with your image-processing software to get results that match the hues of the light at different times of day.

Customizing White Balance

Some sources emit strong casts, like the yellow, green, and blue contributions that result from the mercury vapor in fluorescent tubes. This is where advanced digital cameras offer an advantage with their option to customize the white balance setting by letting the camera assess the color temperature of the existing light. This is useful with mixed light sources. Depending on your specific camera, you can usually point it at any white target (or a photographic gray card) and make an exposure in the existing light. The camera registers this as its default white balance until you change it.

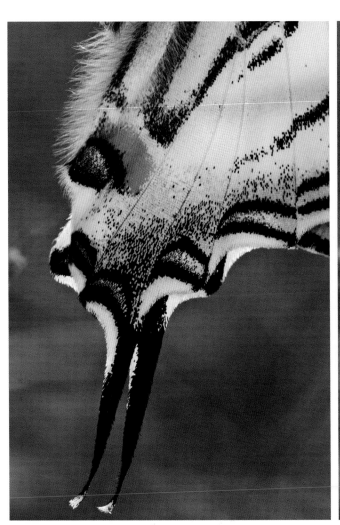
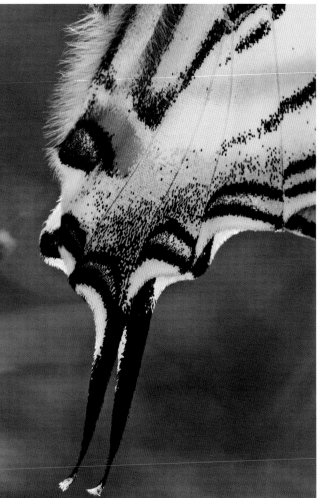

These pictures of swallowtail wings show how color temperature (white balance) changes the overall feel an image, with increasing warmth from Daylight (left) to Shade (right).

What is dynamic range?

Human eyesight recognizes the photographic equivalent of about 10 stops in brightness, ranging from a glimmer in the dark in which shapes are barely discernible to the brilliant white of light reflected from snow. It has an automatic exposure control system unrivaled by anything in the photographic world.

Comparatively, the range of brightness over which a digital sensor can record visible image detail is usually slightly more than 5 stops, which is referred to as the sensor's dynamic range. Thus a digital camera cannot capture the complete range of tones found in a scene from nature. Areas of photos will become burned out (white with no detail) when light intensity is too high, and black when the light level is too low (this is similar to color film in its sensitivity to light). However, as we will see on page 86, you can extend the dynamic range of your photos to approach that of nature by using high dynamic range (HDR) techniques.

A histogram, which we discussed on page 28, shows how tones within an image file are distributed and is perhaps the best tool to assess exposure in a photo. Its graph also maps the dynamic range recorded by a sensor. If the histogram is bunched somewhere in the middle without extending to the left and right axis, the full dynamic range of the sensor is not being utilized. If clipping occurs on either end of the histogram, you know that the scene has exceeded the dynamic range of the sensor. Digital information beyond the ends where clipping occurs—black shadows and blown highlights—is lost and cannot be regained later.

Optimal use of the sensor's dynamic range occurs when the histogram uses the whole scale without clipping.

Remember that your sensor has a dynamic range of about 5 stops. Of the 256 brightness tones in a histogram, you would think that each stop of dynamic range would record about 51 tones (256/5 =51.2). In fact, because a sensor records light in linear fashion, each stop is double the brightness of the one below it. So if you divide your scene into five zones of brightness as shown in the illustration below, you will note that nearly 80% of the tones are found in the Light and Very Light zones.

NOTE: The numbers used in the illustration total 248, not 256. The explanation is simplified to show one zone with twice the number of tone levels as the one

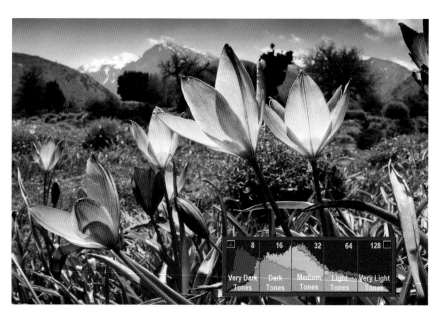

Backlighting, white clouds, a hint of snow, plus foreground detail create an interesting exposure challenge, but the histogram shows a full tonal range has been captured. At the same time, the divided histogram also illustrates the approximate number of tones within each brightness zone, representing one stop, of an 8-bit photo file.

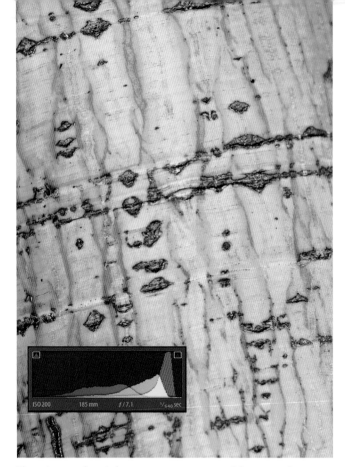

Shooting to the right means to expose with as much brightness as possible without burning out highlights. This optimizes the capture of digital data.

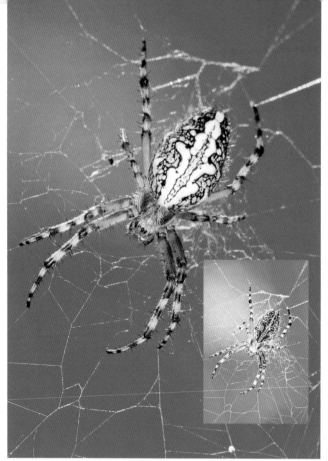

The superimposed image illustrates warnings on the camera's LCD for underexposure (blue) and overexposure (red). I adjusted exposure and fill flash to correctly expose this spider that is backlit by the sky.

below. In fact, each zone has more available levels at its brighter end than at the other, and the overall range is a bit more than five stops, hence the discrepancy.

In practice, this imbalance of bright tones means it is essential to set exposure so that the histogram is as far to the right as possible without clipping and wasting brightness information, because that is where most of the digital data is found. This is known as shooting to the right.

Overexposing a Color Channel

As noted above, if you fail to set the camera for optimal exposure, you limit the dynamic range of the recorded image. Many cameras allow you to view the distribution of tones not just for light and dark, but also for each of three color channels: red, green, and blue. Sometimes, when you have flowers with bright primary colors, for example scarlet poppies or electric blue gentians, a compromise may have to be made in allowing one color channel (red, green, or blue) to be slightly overexposed, because reducing exposure could dramatically cut information from the other channels. It is worth taking a few shots at slightly different exposures to view later on screen.

2

Seeing the Picture

The dramatic subjects captured in macro photography can naturally create pictures with exceptional impact, but you can substantially improve the effect of such photos if you think about the images' compositions. This involves decisions about where to position key elements within the frame, whether or not to fill the frame, how close to the subject you should get, what depth of field should be produced, and how to make use of any patterns or shapes on the subject. In addition, the subject's texture and color may be very important, as can the way you use lighting to emphasize objects in the picture.

There are certainly classic compositional rules that you can follow, but many people have an innate sense of design that may not become evident until they start looking for ways to improve their photography. You may want to ask yourself, "What can I do to improve my artist's eye?"

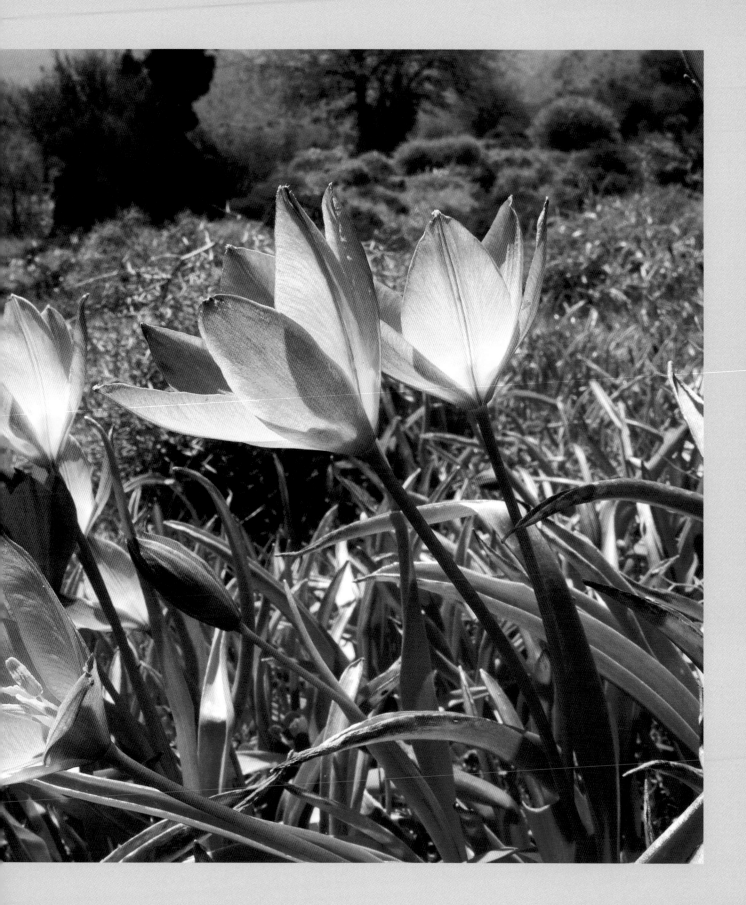

How can I get a good composition?

The camera viewfinder is the frame in which the elements of your pictures must be arranged, which is the essence of composition. Obviously, finding a suitable subject is the first step; but determining where and how it will sit within the frame can make a considerable difference to the overall impact of the final image and to the strength of any message it conveys.

Though placing a subject in the center of the frame may produce an initial impact, viewer interest in centrally composed images tends to wane quickly. Rather, asymmetric compositions create a contrast between areas of greater and lesser interest and lead the eye to shift continually between those areas. The best known and most useful of these asymmetrical arrangements is the rule of thirds.

Placing the point of primary interest exactly in the center of the frame is best done when you can identify a definite symmetry within your subject.

Dead Center, or Off Center?

New photographers are often warned against placing their subject exactly in the middle of the frame. But dead center is the obvious choice for subjects like daisies that feature the type of radial symmetry seen in the spokes of a wheel or the segments of an orange. It can also work for flowers that show bilateral symmetry when you shoot them from directly in front.

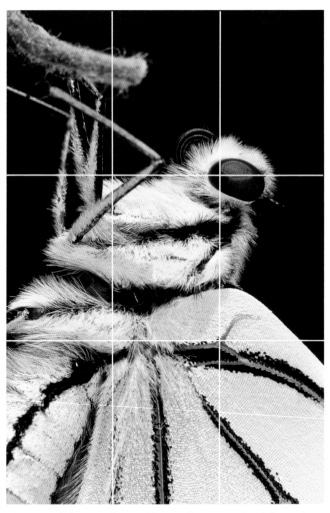

The eye of this swallowtail butterfly is one-third from the right edge of the frame, and one-third from the top, illustrating the rule of thirds.

The Rule of Thirds and the Golden Mean

The rule of thirds is an approximation of what is called the golden mean (or golden section). It is a compositional guideline that divides both the vertical and horizontal dimensions of the frame into equal thirds, like a tic-tac-toe pattern. Important elements within the frame, like an insect's eye or the stamen of a flower, are placed along any of these lines and especially at their points of intersection, where they have the strongest effect on the viewer's attention.

The golden mean is an idea employed since classical times by artists, sculptors, and architects to produce aesthetically pleasing compositions. To create these ideal proportions, divide a line into two sections so that the shorter one bears the same ratio to the longer one as a longer one does to the whole length.

Confused? It's not that difficult. Practically speaking, the golden mean places important elements a little farther into the frame than the rule of thirds. Instead of placing a point of interest 33.3% (or 66.7%) of the way into a frame (rule of thirds), you would place it 38.2% into the frame (or 61.8%). For some as yet to be determined psychological reasons, the slight difference seems to produce a bit more aesthetic appeal.

Dominant Elements

When you divide the photo into three segments (whether rule of thirds or golden mean), you make visual statements about the relative importance of its various elements. For example, if the horizon within a landscape falls on the upper line of thirds within your frame, then the bottom two thirds of the scene tends to dominate. Alternatively, by setting a horizon along the bottom third, the sky becomes the most important element in the photograph.

When shooting wide-angle close-ups of flowers, a subject placed in the foreground will dominate the image, but your camera's position will affect the background and the context. Shooting from slightly above means the ground cover and other plants determine the background; whereas shooting from below sets the subject against the sky, producing a view with arguably greater visual impact.

The Idea of Positive and Negative Space

Lines and shapes in any picture delimit what are termed positive and negative spaces. The positive space is essentially the subject of the picture, and what lies outside it usually forms the background, thereby becoming the negative space. The contrast between the positive and negative elements is an important part in any composition, and the position of the subject determines the balance between these elements.

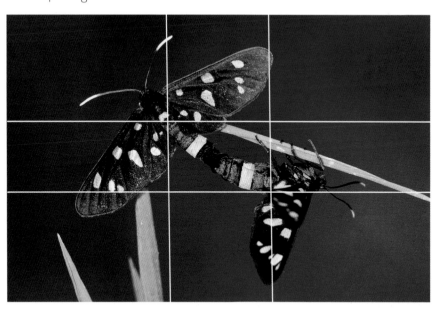

The golden mean is then slightly different than the rule of thirds. Instead of dividing a frame into equal thirds, the golden mean subtly places important lines or points of interest a little bit closer to the center of the image.

Where should I place the camera to get good close-ups?

Sometimes there is little choice about where to place your camera because of where you happen to find your subject positioned. Yet given a choice, you will find even a familiar object, such as the inside of a flower or a feeding insect, can take on an entirely new look when you use care to examine all possible vantage points for photographing. So taking the time to figure out camera placement—especially if the subject is stationary—is extremely important.

An important skill in any kind of photography of natural subjects is to make the commonplace as exciting as the rare. Macro photography offers a head start in this respect because so many familiar subjects appear completely different when viewed from such close quarters. But there is still more you can do to make images appear extraordinary.

It is essential to spend the time necessary to understand the differing effects that can be produced with a variety of lenses. It helps to experiment with a range of focal lengths from wide-angle to telephoto used from a fixed position. A zoom lens is also a useful tool since it can produce differently cropped portions of the same scene from

the same position. A subject such as a set of rocks photographed with a wide-angle focal length will include much more background than the same subject recorded while using telephoto focal lengths, where the subject becomes isolated from its background.

Changing the focal length not only alters how much background is included, but it changes the view of the subject as well. Wide-angle lenses accentuate foreground details since they are closer to the front of the lens. Telephoto lenses produce a flatter sense of dimension where perspective is condensed so that points within a scene appear closer together than wide-angle or normal views.

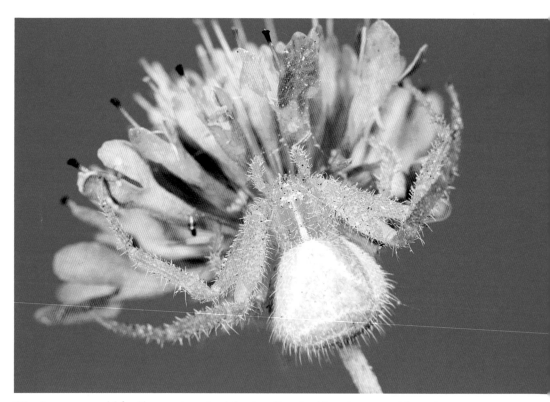

We view our world for the most part while standing, looking down on things that are shorter than we are. One common strategy for recording a variety of close-up shots is to get down as low as possible and shoot up at your subject. This is especially effective if you include a soft azure sky with no distracting details in the background.

Another strategy is to change perspective, which in essence is interpreting 3D scenes in the two dimensions of a photograph. Do this by moving your own position so that the distance between the subject and your camera changes, while using various lenses (or zoom settings) so that the subject remains the same size in a frame. As you change position, the spatial relationship between the objects in your frame and their surroundings will also change.

Experience and instinct work together in choosing an angle for favorable impact. For example, when butterflies have their wings open, then tip-to-tip sharpness should be the goal. To achieve this you should align the camera back parallel to the plane in which the wings lie. This is not always easy, and you might find the butterfly looks too much like a mounted specimen. So try a different view and photograph from head-on while keeping the eyes and the proboscis in sharp focus.

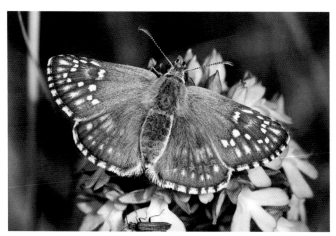 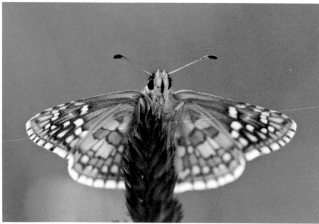

Open winged shots of butterflies are perfect for identification purposes, but they can begin to look like set specimens in a cabinet (left). Here the insect is also viewed from the front with the head in sharp focus (right).

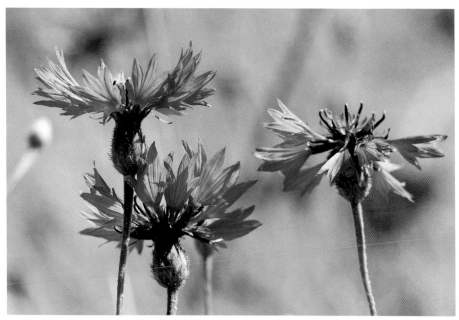

Fields and meadows can sometimes offer a busy background with numerous flowers, stems, and grasses growing randomly. This view of a flower group is rather conventional, but the backlighting to highlight the subjects and the use of a telephoto lens to produce a soft blur sets the flowers apart from their background, while still showing a meadow location.

What are bird's-eye and worm's-eye views?

Try to hold your camera so the sensor's plane is perfectly parallel to the flat surface you are photographing when recording from above eye-level.

Well, this is a question you probably can figure out pretty easily. A bird's-eye view is when your camera is placed above your subject and is pointed directly down at it. This is good for things lying in a flat plane, such as fallen leaves, patterns made by ice, dried mud, etc.

Alternatively, a worm's-eye view is when you get down to photograph from the level of your subject (or even below it). Wide-angle and extremely wide-angle close-ups taken from below will often produce a high-impact image. One example is to shoot a flower against the sky, especially when you find a way to light the flower against the brighter background. This viewpoint is easier to accomplish with relatively large subjects where you have room to move the camera a bit, like taking pictures of groups of flowers or subjects on boulders. An

LCD that swivels or a right-angled viewfinder are great bonuses for those situations where a camera needs to be really close to the ground.

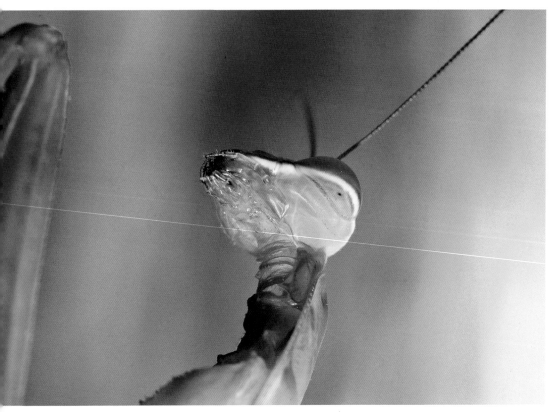

The Praying Mantis (Mantis religiosa) is a photogenic creature. The view from below was an obvious one since this female had climbed high on a vine. These insects seem to have a knowing look, and this is emphasized by the worm's-eye view.

Should I use portrait or landscape orientation?

Like the classic 35mm rectangular film format (36 x 24 mm), most sensors in DSLRs have an aspect ratio of 3:2. The Four Thirds sensor format and many point-and-shoot models have an aspect ratio of 4:3, also rectangular. Holding the camera so the long side of the viewfinder is horizontal results in what is called the landscape format, while turning the camera so the long side is vertical produces a picture in the portrait format.

The shape of a subject will usually dictate the format you select, with wide objects requiring landscape format and tall objects calling for portrait. But good photography eschews predictability. Though wide-angle lenses suggest the landscape format, you can capture some very interesting views of a scene when turning the camera to use portrait format.

The potential use of the image can also dictate choice. Even if some flowers arranged along a stem look better in portrait format, a horizontal picture might be mandatory to print in a calendar. If you are unsure before taking the picture about which format to use, you can always record both ways. Or shoot the subject so that you have space to crop during your post-production routine.

It is important to consider beforehand where you want to put the horizon. Again the answer is to take a number of shots to cover all eventualities. Some cameras allow you to specify the format of the image file, or you can crop in post-processing to the shape that works best. You might want the extreme landscape look (16:7 aspect ratio) or what has become widescreen (16:9). If you see something that might be publishable as a background on a website or a potential cover for a book or magazine, remember not to compose too tightly. Room is always needed at the edges of the frame for a designer to impose their own crop or to place titles and logos.

Landscape format suggests a view of the world as seen through two eyes. Though conventional wisdom suggests that wide-angle lenses should be used in landscape mode, turning the camera to give a portrait view can sometimes result in an equally pleasing, if not more intriguing, picture.

How can I make the most of shallow depth of field?

What is it that makes one photo with blur a good picture while another one may simply be an out-of-focus mistake? It is not always easy to analyze this, but you will often find that the good close-ups include an object or two that are bitingly sharp to contrast with the blurred portions, and these focused objects are placed at areas of interest within the frame.

Perhaps most importantly when recording small creatures is to concentrate on their eyes. Shallow depth of field in a close-up wildlife photo can almost always work as long as the eyes are in sharp focus. That's because viewers will often ignore details that are less than sharp as long as the subject's eyes are clearly focused. Conversely, a photo can seem off or wrong, even if you cannot put your finger on exactly why, if the eyes are not optimally sharp.

Elements in certain positions within the frame will always draw your eye towards them. Alternatively, blurs of color and soft shapes can also have considerable abstract appeal. Some people

Focus on the eyes every time when shooting insects and small animals, because they are our first and most important points of contact with other living creatures.

seem to have that "artist's eye" and intuitively frame a subject so that it forms an attractive design within the viewfinder, all of which has to do with composition, which in its simplest sense is the arrangement of components within a picture to create visual impact.

There are certainly guidelines that you can use to improve your compositional skills (see page 36), particularly when determining what should be sharp and what can be less so in a photo. But the most eye-catching shots are those that break the rules. Part of the process of growing as a photographer is in recognizing the opportunities for doing that. Even the greatest photographers produce a large proportion of pictures that are not as good as others, and those photos that reach the highest echelon of "specialness" are not as common as you might think.

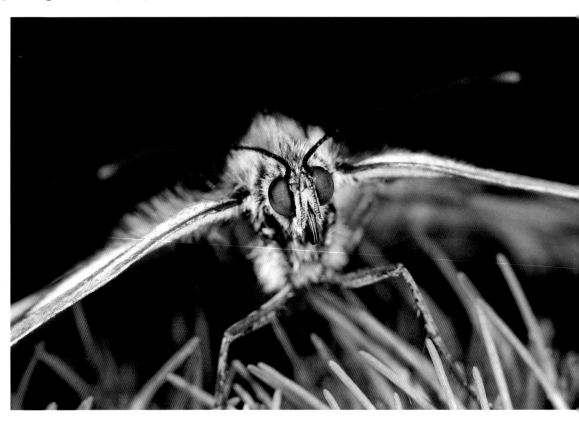

What's the best way to capture textures?

The nature of a surface—whether rough, smooth, shiny, or dull—is an important part of any composition. This gives texture, which is a pictorial element that you can accentuate to create a mood. On the small-scale with our chosen subjects, texture is created by those minute details such as ridges, lines, furrows, spots, depressions, etc. on the subject's superficies. When lit properly, particularly from the side, these details cast small shadows that create relief, which helps enhance the impression of sharpness.

If light falls straight on the subject, the image will look flat because the tiny shadows are suppressed. If you use a single light source to one side, the shadows that are cast might be too harsh. This makes a second light very helpful to serve as fill light, which will soften harsh shadows. But a fill light has to be used with care with insects, because if not positioned correctly, shadows can create the illusion of an entire extra set of legs.

When using a macro flash system to create relief, keep the flash heads reasonably close to the subject so that the light comes from the sides. On the other hand, if your intention is to provide soft, shadowless illumination, then the lighting needs to be close to the lens axis. Here it is probably best to use a flash unit with a diffuser or, better still, a ring flash. Texture is particularly important when working in monochrome.

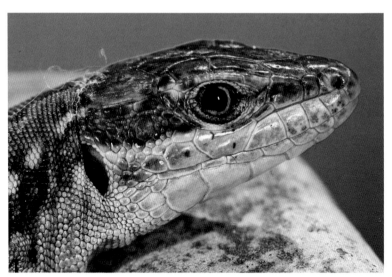

Reptiles, far from being slimy as many think, often have skin with interesting bead-like structures. A degree of side lighting works well to emphasize this type of surface.

Texture is an important element when photographing lichen. You can accentuate it with a burst of flash from the side to create relief or use natural side lighting early or late in the day. The sunlight at those times of day is more yellow than a flash, and will therefore highlight the warmth in the colors of the subject.

How can I use background colors effectively?

Brightly colored subjects such as scarlet beetles and blue or yellow flowers immediately grab attention, producing an impact that can be strengthened when they are set against backgrounds that are darker or are a complementary color. Neutral backgrounds in nature, such as gray rocks, tan tree bark, or the greens and browns of vegetation, can work well as backgrounds, especially if you throw the background out of focus to produce a soft blur (i.e. desirable bokeh, see page 23).

Controlling background is essential for photographs where the subject dominates the frame because background colors and details will distract from your subject, leading to confusion or ambiguity if they lean toward garishness or structural complexity. About the only exception I can think of occurs when you deliberately try to show the camouflage traits of a

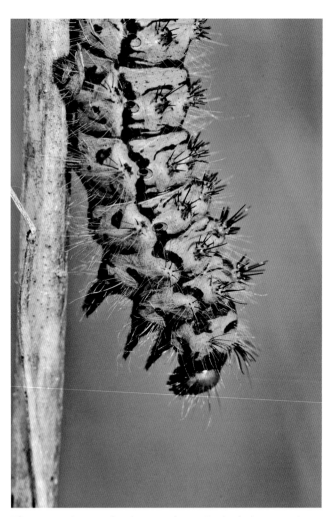

The neutral green background, particularly because it lacks competing details, helps viewers focus on the yellow and black colors found in this caterpillar.

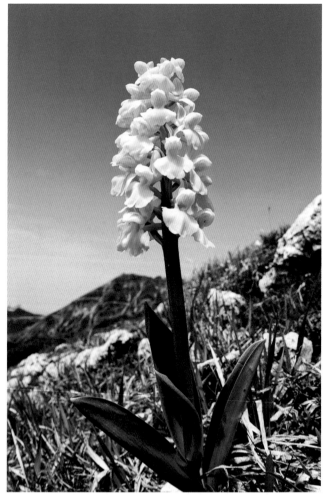

In using color to isolate the subject from the background in this landscape, the blue sky is a nice complement to this pale yellow orchid.

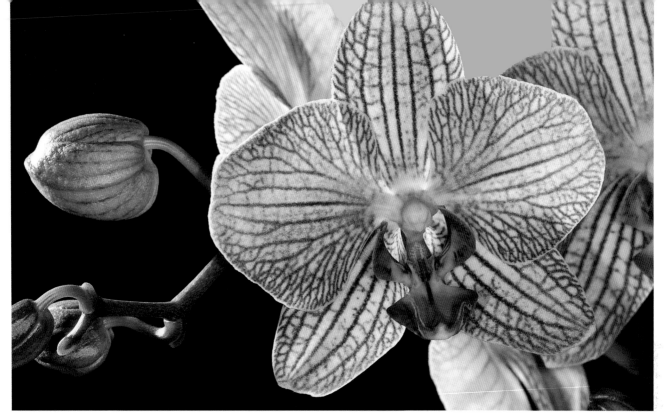

subject, in which case less contrast between the subject and the background will demonstrate the effectiveness of its disguise.

Black backgrounds often arise as a consequence of using low-powered flash units close to a subject because light intensity falls off quickly behind the subject, becoming insufficient to illuminate the background. You can avoid unintentional black backgrounds by having the background close to a subject so it too is illuminated by your flash; or learn how to create them deliberately, either through fall off of light or placing black material such as flock or velour paper behind your subject. Black is not natural in many cases, but photographers sometimes utilize it to accentuate and enhance colored subjects, though it's my experience that black backgrounds have a tendency to go in and out of photographic fashion over time.

Pure white backgrounds are gaining in popularity (see page 124), especially those lit from the rear to act as a backlight and accentuate transparency in a subject. They produce results evocative of the best natural history art.

Flash will light a close-up subject, but as the light intensity diminishes as it travels away from its source, background elements that are not immediately behind the subject will be underexposed, turning dark or black.

The background is an integral part of this photo, not merely a neutral backdrop for the fuzzy, mossy-colored lichen spider that nearly disappears into its environment.

How do shapes affect composition?

Some pictures have the capacity to draw you in time and again, yet you may not be able to say precisely what appeals to you. The reason may very well be the way that subject elements work at a subliminal level to make form shapes within the frame. This might be as simple as composing a shot that contains sets of lines, capturing several insects instead of one, or perhaps framing a group of berries that forms a complex series of shapes such as triangles or rectangles. Sometimes curves from the shape of an animal's body or a plant gently wind through the picture.

Framing shapes requires that you zoom in and out with the lens or physically move your camera toward and away from the subject, then turn or twist the camera as required to fit the desired composition within the frame. You must be willing to alter your viewpoint until the picture looks right, perhaps changing position from head on to a side approach, or getting down to shoot your subject from below or standing to shoot it from above. It takes time to try out the options as you move in close to your subject and then back a little, letting it dominate the field of view to a greater or lesser extent; but after a while you develop an instinctive approach, quickly recognizing how best to frame the subject and from what perspective.

Studying your subject within the scene helps you develop your artistic sense and visual flair. You will notice how much you improve over time by taking lots of shots and dispassionately analyzing your pictures, either alone (not easy) or perhaps more effectively with an objective friend. But when all is said and done, unless you are trying to sell your pictures, the person you most have to please with your photos is yourself.

Sometimes shapes appear that are not subliminal, but quite obvious. The key then is to move your camera in such a way to position the shape within the frame to produce an interesting composition.

These intersecting lines on the bark of a birch tree are reminiscent of an inverted pyramid. The abstract geometry creates interest in this simple natural subject.

How close is too close?

A valuable discovery beginning photographers often make early in their learning curve is to move in closer when photographing groups. Groups look much better then because they aren't isolated in the center of the frame with areas of wasted space all around.

Likewise, an effective technique to keep your close-up imagery fresh and to record dramatic shots is to move in very close, concentrating on a part of your subject that makes an interesting shape or pattern in the viewfinder. This is overfilling the frame, which allows you to create fascinating abstracts out of the simplest subjects. As you get close and look at the scene through the viewfinder, various parts of the subject will suggest themselves as images: eyes and heads, body structures or forms, interiors of plants, or perhaps the textures of mosses.

Overfilling isn't the only way to go. Depending on your purpose, a variety of views yields different types of close-up photos. A wide-angle lens, for instance, produces shots that contain background information about a subject's habitat. On the other hand, this habitat information is lost if the subject is too large in the frame, though overfilling by using a telephoto lens isolates the subject and allows viewers to concentrate on the details of the subject. In order to provide a sense of scale and reality to your macro images, you should think about mixing these various types of shots in a series.

One tip when trying to overfill the frame while photographing insects is to start from outside their "circle of fear" and move steadily closer as you record, trying not to disturb your subject. This should insure you get at least some photos to begin with, because you may not get any photos if you start too close and cause your prey to scamper or fly away.

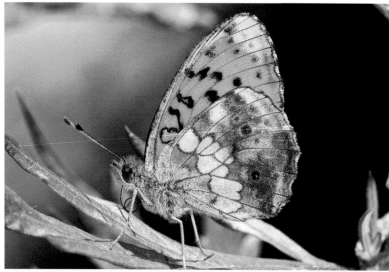

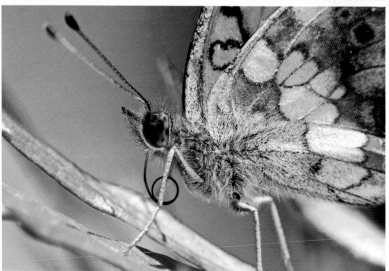

Filling the frame with only a portion of the insect creates a more de-tailed, visceral and focused shot than merely recording the entire insect from farther away.

Making
the Picture

It comes as something of a surprise to many people that you can take superb close-up shots with both sophisticated cameras that use a range of various lenses, and also with much simpler, more portable equipment.

Most people start modestly, get hooked, and then find that, bit by bit, they want to experiment with different kinds of photographic techniques—wide-angle close-ups, macro flash, and lens stacking, to name a few

This section gives a thorough treatment of what lenses will do, the secrets to great lighting, and will even provide guidance for building some of your own equipment to get larger-than-life shots. Be warned! This area of photography is highly addictive.

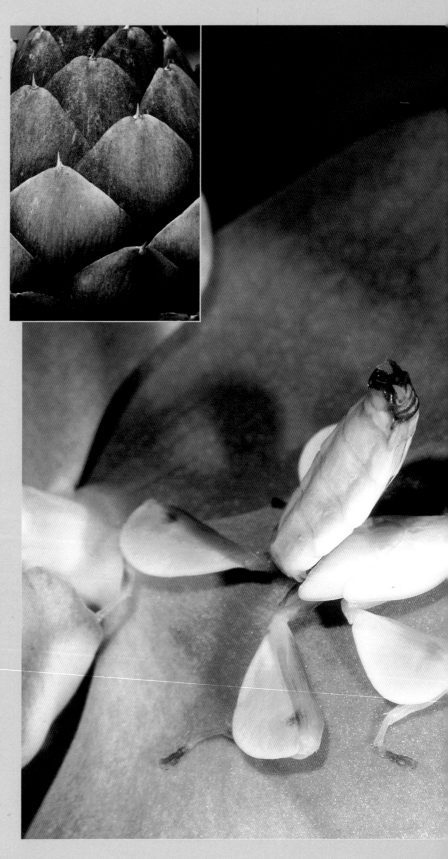

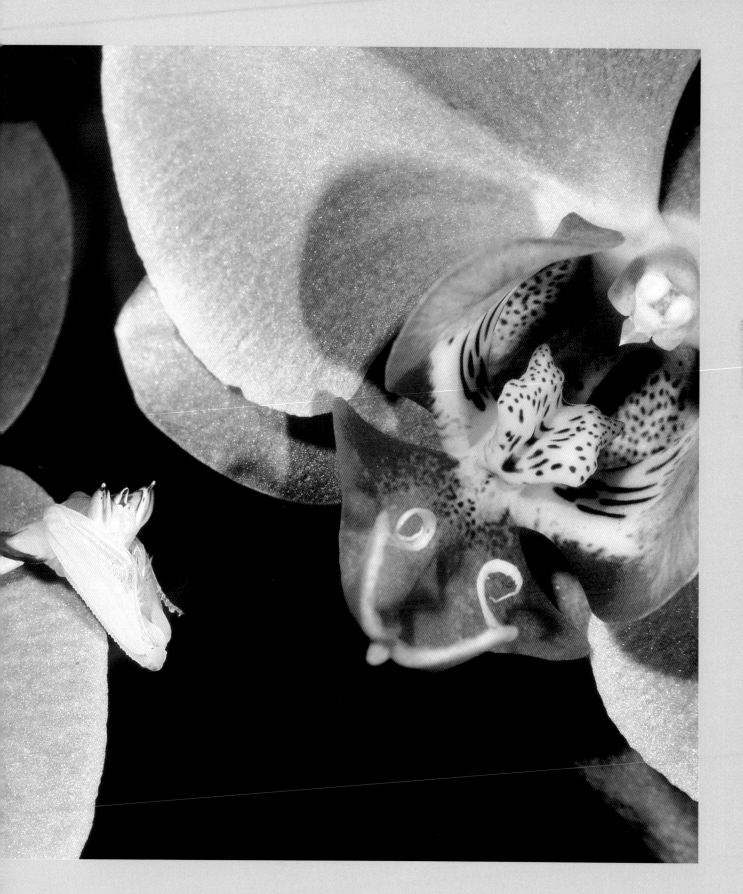

What macro lens should I choose?

The quality of modern macro lenses is excellent, whether they come from your camera manufacturer or an independent maker. Further, almost all offer the capability of producing life-size magnification on the sensor without resorting to teleconverters (see page 52), extension tubes (see page 55), or supplementary lenses (see page 72). In strict terms, this means their unaided range ends at 1:1 magnification, which is where macro photography begins; but still, everyone knows them as macro lenses.

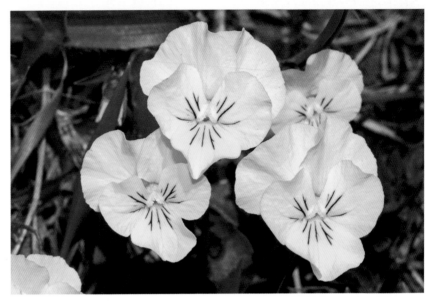

A 50-60mm macro is an excellent general purpose lens for use with a range of subjects. It works particularly well with flowers and with bugs that are not sensitive to your presence.

There are three distinct ranges of focal lengths for macro lenses and, not surprisingly, they all have their aficionados. Your choice will probably depend on the nature of the subjects you want to photograph.

50–60mm (standard): This range is sometimes held as the best for flowers, fungi, and animal subjects that will not be scared off by the inevitable closeness of the lens front when you move towards a life-size (1:1) reproduction ratio.

90–105mm (portrait): This medium telephoto range is better for butterflies and other small creatures because there is a greater distance between lens front and subject. Many photographers like it for flowers because of its slightly flatter perspective compared with 50–60mm macro lenses. That flat perspective also means it does not distort human faces, so it can double as a high-quality portrait lens.

150mm, 180mm, and 200mm (tele-macro): These lenses were once considered exclusively for professionals, mostly because of their high cost. They are now a popular choice for macro because of their excellent optical quality. In practice, the subject can be photographed from farther away and still be pulled out of the background, because the softness these lenses produce in backgrounds helps accentuate a sharply-defined subject.

Depending on focal length, you may notice a difference in light fall-off behind the subject when shooting with macro flash. This tends to be more pronounced with the shorter focal lengths. In practice, the fall-off will not make much of an impact if your subject is close to the background.

My choice is the tele-macro range for the natural way it isolates subjects against backgrounds and because it allows me to be far enough away from the subject to avoid disturbing it, particularly if it is a live creature. I can then record it in a more natural way.

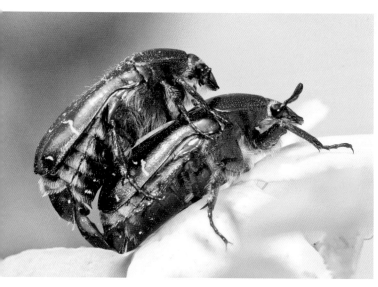

A 150mm macro lens isolates these mating rose chafer beetles from a background that it renders as a soft blur, emphasizing foreground sharpness.

A 100-105mm macro gives that extra bit of distance when you don't want to get too close to your subject, either because it is aware of your presence or is something, like some plants or insects, that could sting, prick, or irritate your skin.

With a foreground subject, the lens choice would probably be an ultra-wide-angle lens with a close focusing capability (e.g. 15mm rectangular fisheye, 20mm, or 24mm).

What does a teleconverter do?

A teleconverter, also known as a multiplier, is a highly corrected negative lens (concave) often comprising a half dozen or more elements. In a DSLR, it is placed between the camera's body and the regular lens. The converter spreads out the light from the lens to which it is coupled, thereby magnifying the image on the sensor. However, this will exaggerate any lens imperfections. It is therefore important to use a high quality teleconverter and the best lenses you can afford.

Changing Focal Length

Adding a teleconverter behind any lens set on infinity will multiply the focal length and, because it spreads out light, reduce the intensity of light reaching the sensor. A 1.4x converter will spread light to cover double the sensor area, in effect halving brightness to produce a light loss of one stop. The net effect is that using a 1.4x teleconverter transforms a 150mm f/2.8 macro lens into an equivalent 210mm f/4 macro lens, and a 2x produces a 300mm f/5.6 equivalent (losing two stops).

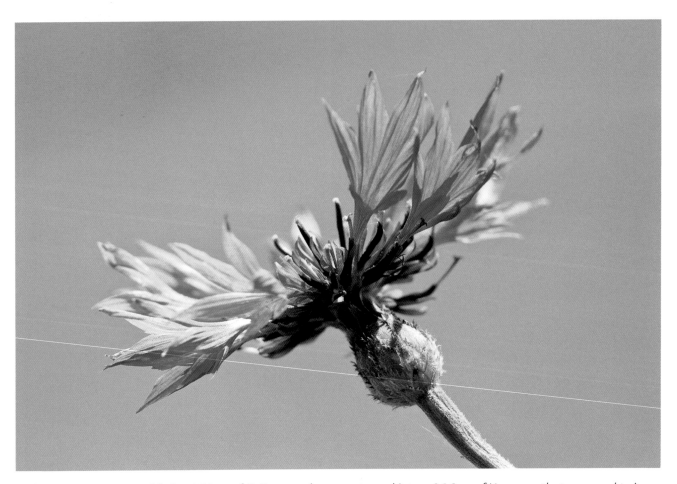

With a 1.4x converter added, a 150mm f/2.8 macro lens was turned into a 210mm f/4 macro that was used to isolate a single cornflower (Centaurea cyanus). Though this photo could have been made without the teleconverter, the added focal length enhanced the soft background bokeh.

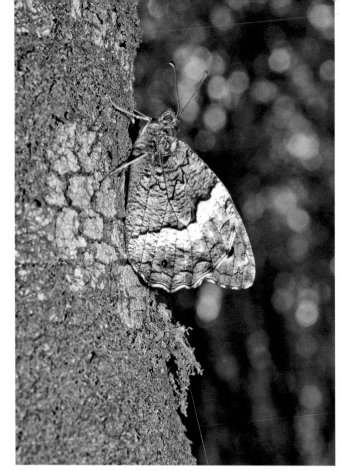
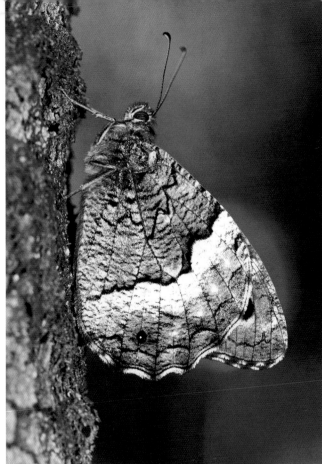

These images of a woodland grayling butterfly (Hipparchia fagi) show the results of using a 105mm f/2.8 macro without (left) and with (right) a 1.4x teleconverter. Not only is there increased magnification, but once again note how the background becomes smoother with fewer obvious highlights.

The lens/teleconverter combination will still produce the lens' original 1:1 reproduction ratio, but it allows you to record at an increased distance from the subject, which is handy when photographing skittish insects, small lizards, mammals, etc.

Teleconverters can also be used to boost magnification further by placing an extension tube between the lens and the teleconverter.

Image Quality

Photographers sometimes warn about using teleconverters with lenses set at their widest apertures, claiming there is a deterioration of image quality (unless both lens and converter are of the highest quality).

However, close-up photographers more often use small apertures as a matter of course, which allows the light rays to pass through a lens system close to its central axis. This is where all lenses, teleconverters included, are best corrected and, as a result, image quality using a 1.4x multiplier is all but indistinguishable from using the macro lens unaided. There can be some slight visible image softening with 2x converters when the prime lens is stopped to f/16 – f/22 because the 2x multiplier creates an effective aperture of f/32 or f/45 respectively. Diffraction softening becomes obvious at these apertures.

Why shoot with wide-angle lenses?

The advice for better wide-angle shots has always been to compose with an object or two in the foreground, such as rocks, trees, or flowers, and to set the camera in a low position. This creates visual interest and leads the viewer's eye into the frame. This advice holds true for successful wide-angle close-ups and macros. The trick is to find an element within the close-up frame—perhaps a part of a leaf or a portion of an insect's body—that can lead the viewer to the dominant subject of your image. Move in as close as your lens will allow so that the background becomes a secondary consideration, giving context to the foreground.

The wider the angle of view (shorter the focal length), the greater the distortion of perspective, which is created by exaggerating the parts of a subject closest to the lens. This technique works well with flowers and plants to deliver a photo with impact, but it has to be used with care with animals' faces since the foreshortening of facial features exaggerates protuberances (noses), and viewers often find that degree of distortion disturbing.

What Focal Lengths Work Best?

Shooting close-up with a wide-angle lens is not always a question of focal length. The real advantage lies with a generous thread in the focusing mechanism that lets the lens focus as close to the subject as possible without blurring. Fixed-focal length lenses tend to be much better than zoom lenses in this respect, and their manual versions are best of all; although there are a

The fall colors of these Italian maple leaves (Acer italica) contrast with the blue sky. The sense of space was achieved with a foreground subject composed using a 15mm f/2.8 rectangular fisheye lens on an APC-S sensor so that distortion is not strongly evident.

number of excellent AF lenses that focus closer than most, including the Sigma 20mm, 24mm, and 28mm lenses, all of which offer a f/1.8 maximum aperture.

When it comes to zoom lenses, there is often a macro setting, but this works most effectively at the longer end of the zoom's focal-length range. The best bet for recording wide-angle close-ups with a zoom is with a 2x lens, where the longest focal length is twice that of the shortest (e.g. 12–24mm, 16–32mm, and 10–20mm). I have a 16–85mm lens that is a wonderful general purpose zoom, but it cannot focus close enough to the subject without using an extension tube (which preserves the wide view, whereas a teleconverter does not).

A single narrow extension tube (8mm) used with a 28mm wide-angle lens gives a sense of the world inhabited by this crab spider (Thomisus onustus) as it hides behind a flower, ready to pounce on visiting insects.

Getting Closer with Extension Tubes and Bellows

When you want to get nearer to the subject than even your wide-angle close-focusing lens allows, the traditional way is to use an extension tube, which increases the distance of the sensor from your lens. Wide-angle lenses have a short focal length, so just a small extension produces a big increase in image size and takes you very close to the subject. An extension tube that is 12mm long seems to be the minimum length available that couples electronically to a lens. Though it is best to switch off AF to keep a lens from hunting for focus, you still need the electronic coupling to adjust the f/stop since many lenses are made without a mechanical diaphragm and cannot be stopped down with a non-auto tube.

A bellows is a continuously variable extension tube with a camera mount at one end and a lens mount at the other. Its length can be finely adjusted with a rack and pinion drive to provide different degrees of magnification. As a unit, the bellows with camera plus fitted lens is moved using a second rack and pinion on a rail that is fitted to a sturdy tripod. Some camera functions, such as autofocus, are not available when using a bellows. A bellows is great for studio use because you can mount all types of lenses on them for close-up shooting. But Novoflex is the only maker that produces bellows light enough to be used in the field.

What quick tips will improve my wide-angle close-ups?

Using wide-angle focal lengths to enhance the strength and impact of your close-up photos is not particularly more difficult than any other type of photography. But like shooting portraits, landscapes, sports, street scenes, or other genres, there are basic concepts you should learn and remember to think about as you anticipate making your close-up or macro shots.

Consider positioning: When using a wide angle to set subjects in the context of their surroundings, you might need to get lower than you think—often down to the ground. A low support, such as a sturdy minipod or beanbag, is helpful. Getting your camera underneath flowers or fungi gives a bug's eye view. The subjects loom over the lens, giving a viewpoint that is out of the ordinary, thus one with added impact. To get as low a perspective as possible, set the camera on the ground and use a right-angle finder to help you see through the viewfinder. Some cameras come equipped with LCD screens that fold out and offer live view, which are also useful for placing the camera very low.

Control depth of field: You will need to set apertures at f/11 and smaller to maximize depth of field when working with a wide focal length. At f/11, the background will be slightly soft with shapes such as mountains or trees still recognizable. Smaller apertures bring these into focus, with complete front-to-back sharpness, which sometimes may be too busy and distracting. A depth-of-field preview button is useful for checking how much of the background is in focus. If in doubt, take shots at a series of apertures from f/8 through to f/22 and choose what looks best to you.

Be aware of the magnification gap: You will find smooth and continuous changes in magnification when using zoom and macro lenses as you either change focal lengths or move closer, respectively. However, there is a leap in magnification when you add an extension tube that leaves a "gap" in terms of

A wide angle (10-20mm zoom) enables a group of orchids (Serapias neglecta) to occupy the foreground—the slight distortion works well with flowers, increasing their prominence.

magnification. For example, at its closest focus distance, a 20mm wide-angle lens may have a maximum magnification of 0.125x. When used in conjunction with a 8mm compatible tube, it no longer focuses on infinity; instead the magnification range extends from 0.38x to 0.5x (at the closest focusing distance to the subject). You won't be able to utilize magnification factors between 0.125x and 0.38x unless you can find a narrower extension tube. 8mm is the narrowest that is currently manufactured, though 12mm is the thinnest available for most systems.

NOTE: Some independent wide-angle lenses offer a better close-focus capability than those from camera manufacturers (e.g. Sigma 20mm f/1.8 with 0.25x magnification at its closest focus).

Don't get too close for comfort: If you compare the results when recording half life-size magnification using a 20mm lens and a 28mm lens, you will see quite a difference in the amount of background recorded.

Be aware of subject sensitivity: Bugs and beetles might let you get very close with your wide-angle lens, say to within one inch (2.54 cm) or less, but butterflies won't, unless you set up your camera near a suitable flower and wait with a remote shutter release of some sort. Otherwise they will respond with a fear/flight (literally) reaction if you hold the camera and suddenly move in extremely close. Moving close to lizards or salamanders takes patience and good stalking technique—you might get one good shot before they run off.

Watch out for shadows: You risk casting a shadow over your subject if the sun is behind you. Consider maneuvering into a different position or try to use flash. Reflectors can be tricky with ultra-wides since they can easily end

up within the periphery of the frame without being noticed until after you've taken the photo.

Mix and match: Wide-angle shots take the viewer to interesting viewpoints, but don't rely entirely on this approach. Shoot a variety of close-up shots and long shots, too, or you can mentally numb your viewing audience!

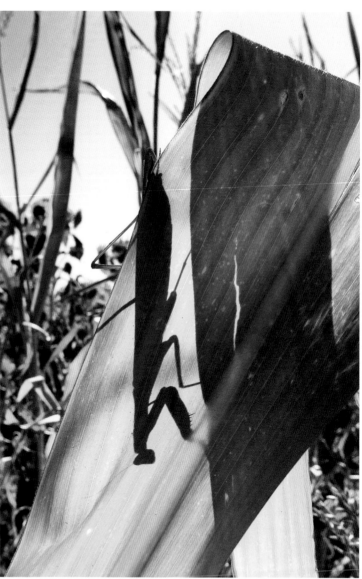

The wide-angle view from below is coupled with backlighting that produces a silhouette, generating a sense of menace. Many photographers find that working with wide-angles inspires a kind of creativity they did not realize they had.

What is a rectangular fisheye lens?

The word fisheye conjures up those perfectly round photos that offer a 180° panorama. Whether you get that type of image by using a special circular fisheye lens or an accessory add-on, these images quickly appear gimmicky with less appeal.

Rectangular (also known as diagonal) fisheye lenses, however, are different. They neither produce circular images nor do they record a true 180° horizontal panorama. Their name comes from the fact that they give a 180° diagonal field of view. This is exciting because they offer a remarkable close-focusing capacity that brings your camera closer to your subject than other wide-angle lenses, permitting dramatic close-ups.

Such lenses when leveled horizontally will render lines near the center of the viewfinder as horizontal. But straight lines will show barrel distortion and begin to curve if you tilt the camera and lens slightly up or down. The effect on other shapes is less noticeable but still gives a distorted perspective.

Many of the rectangular fisheye lenses available are legacy lens designs created for 35mm film and thus fully cover the FX format sensors. Of course you will need a diagonal fisheye lens that mounts on the camera you own. I use a couple of older rectangular fisheye lenses, a 15mm f/2.8 and a 10mm f/2.8, on my APS-C camera. To give you an idea of the closeness you can achieve with these types of lenses, I can bring the 15mm lens to within 2.75 inches (7 cm) of a subject (0.26x magnification; 1:3.9 reproduction ratio), and the 10mm to within 0.67 inches (1.8 cm at 0.33x; 1:3.3) at a 15mm focal length equivalent. Since APS-C format sensors record only the central portion of an FX lens' image circle, the 15mm rectangular fisheye actually produces little distortion at its 22.5mm focal length equivalent. Such arrangements function superbly as very close-focusing ultra-wide setups, though distortion at the edges of the frame is clearly more noticeable with the shorter lens.

I find myself using the 15mm lens more often, especially for setting plants in the context of their environment. In addition to producing less distortion,

Now this is a low point of view! The camera sat on a beanbag and a right angle view-finder was used to focus comfortably. The perspective distortion is considerable with objects close to this 10mm f/2.8 rectangular fisheye lens.

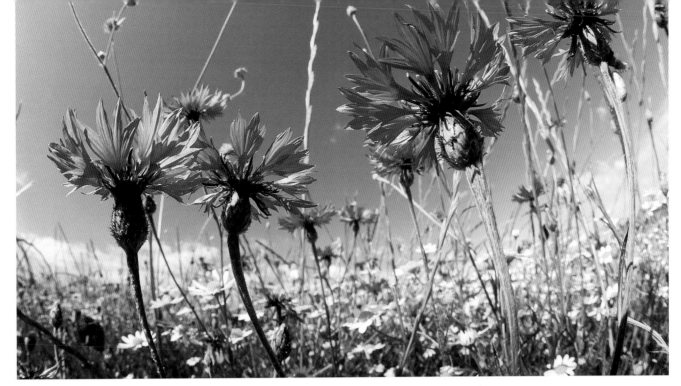

A rectangular fisheye capturing cornflowers (Centaurea cyanus) in the foreground demonstrates that horizon lines away from the center become curved. Some find this distracting, while others find that it makes for a standout image.

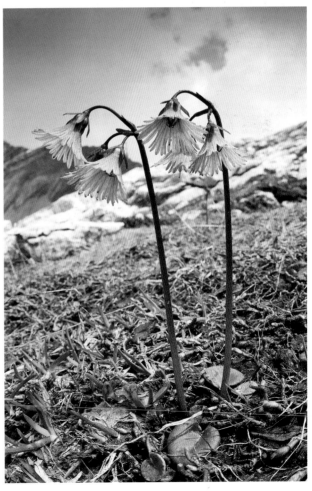

the fact that the front lens element is a bit farther away (but still close) makes it more practical (though it is by no means easy to use with skittish insects). However, the 10mm is great for getting the camera down on the ground (using a right-angled viewfinder or foldout live view LCD) to create a dramatic bug's eye view of leaves, grasses, blossoms, and the occasional inquisitive insect or slug. It lends itself to those occasions when you know you want a view that is unusual and out of the ordinary.

I have always adored alpine flowers and the way they seem to explode just as the snow melts, like these delicate snowbells (Soldanella alpina). For a slightly different view, and to emphasize the bells, they were photographed from below with a 15mm f/2.8 rectangular fisheye. Edge distortion is not obvious since the APS-C sensor recorded only the central part of the image field.

Should I use flash?

Daylight is the unrivaled light source for nature photography. With flowers, for example, you cannot beat the quality of diffused light from light cloud cover. Recording sharp close-ups in daylight is now more successful than ever using DSLRs since they perform superbly at high ISO values, which allows fast shutter speeds at small apertures

However, flash has often been used to provide illumination where light levels are low, and it is also fast enough to prevent most blurring effects of subject or camera movement. As we'll see further in the next Question about proper exposure, flash is a great tool to optimize illumination. But the goal should always be to create results that look as natural as possible (unless for some reason you deliberately want to do otherwise). This includes knowing how to avoid unwanted black backgrounds, lightening foreground subjects while the sun lights the scene's background, filling dark shadow areas or to produce more intense colors.

Moving closer with a macro lens, which magnifies the image on a sensor, creates a perennial problem for close-up photographers—shallow depth of field. Flash provides a convenient solution. You want to set a smaller aperture to increase depth of field, but that decreases light onto the sensor. So you compensate by using a higher ISO or a slower shutter speed. But slower shutter speeds mean that the slightest camera or subject movement will cause blurring. With flash, however, the burst of light occurs in a movement-stopping millisecond.

What Are the Flash Lighting Options?

No flash: This is increasingly possible in many situations for those who have cameras that can be used at high ISO settings with little apparent image deterioration. Close-ups during daylight become possible using an aperture of f/16 and a shutter speed of 1/250 second or faster to freeze movement.

Built-in flash is convenient and often works well for close-ups with a medium zoom lens (e.g. 18-85mm) or a 105mm macro lens. However, be careful about moving in too close with your lens because it can obscure light from the flash and cast a strong shadow.

Built-in flash: This can produce good results as long as you use a macro or zoom lens with a focal length of 105mm or shorter—any longer and the flash is underpowered. Additionally, these flashes are rarely positioned high enough, causing the front of the lens to often cast shadows onto the scene.

You can mix light from the built-in flash with background light, producing added punch to colors. To do this effectively, set the camera in Manual exposure mode and point at the background. Set exposure to about a full stop below the correct value as indicated on your camera's linear scale in the viewfinder. Your camera's compatible flash system will take care of subject exposure, though you may have to experiment a bit with the settings.

Off-camera flash, including macro flash systems:
Positioning an accessory flash unit off-camera via an extension cord (or radio control) creates contrast and relief because off-axis illumination produces tiny shadows on the surface of a subject, enhancing texture and aiding the perception of sharpness. Additional techniques include:

- Hold a single flash unit with one hand while pressing the shutter with the other. Check playback and use a diffuser on the flash or a reflector opposite it if resulting shadows are a bit harsher than you like.

- Multiple flash units offer versatility: One flash can be used as the main light while another as fill to lighten shadows. An additional unit can be positioned away from the camera to illuminate the background, thus creating optimal balance between flash and ambient light.

- You can control light intensity by changing the distance of flash units from the subject (or by adjusting their power ratio). The inverse square law says that the quantity of light is proportional to the square of the distance from its source. Doubling the distance reduces the light to one-quarter of its present strength (a loss of two stops).

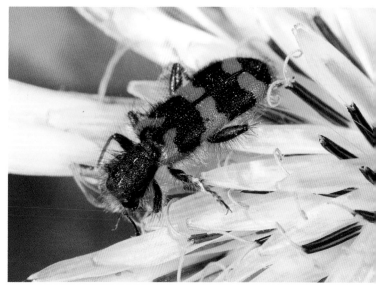

Choosing not to use a flash is feasible with many of today's DSLRs that deliver excellent quality at higher ISO ratings than ever before. This predatory beetle (Trichodes alvearius) was recorded on a sunny day at ISO 400 using f/16. On dull days and in shade a flash offers a definite advantage for controlled lighting.

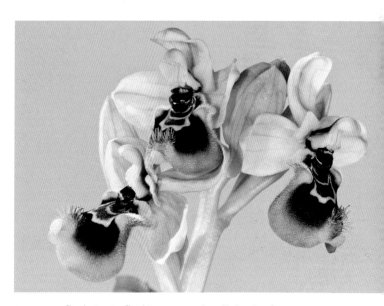

A macro flash (twin flash) was used to light the foreground, but the camera shutter speed was set to capture the ambient light, in this case the blue sky. The soft background was obtained by using a 150mm f/2.8 telephoto macro lens.

How can I improve my exposure?

Exposing properly is your continual challenge when dealing up close to your subject with rectangular fisheyes and other wide-angle lenses. Conventional wisdom would have you keep the sun behind you over the left shoulder. But that will cause the front of your lens to cast a shadow directly into your beautifully sun-lit scene. So you move to avoid that and suddenly find very bright patches of sky in the background that wreaks havoc with your camera's metering system. What can you do?

There are several different compositional and lighting techniques that can help you record well-exposed close-ups with wide-angle lenses. Try shooting from slightly below your subject. For example, insects on flowers above the camera with blue skies behind offer the ideal conditions with an ultra-wide lens. Also, set up so you avoid white patches of sky in the frame. Break up such bright areas whenever possible by composing with trees in the background, or use the incredible graduated filter tool in such programs as Adobe Lightroom to fix overexposed portions that you happen to record in your photos.

Further, you can try metering for the sky while mixing that natural light with fill-flash to help illuminate foregrounds—just don't overdo the flash. This can often work well, though there is a risk of leaving a band of shadow in the middle of the image field.

Perhaps the most sophisticated way to light a wide-angle close-up, though certainly not the least expensive, is to use a specialized macro flash unit, which typically consists of two small, diffused flash heads that attach to either side of the lens. Alternatively, an accessory flash unit placed off camera with a diffuser is also extremely effective. You have to experiment to achieve harmony

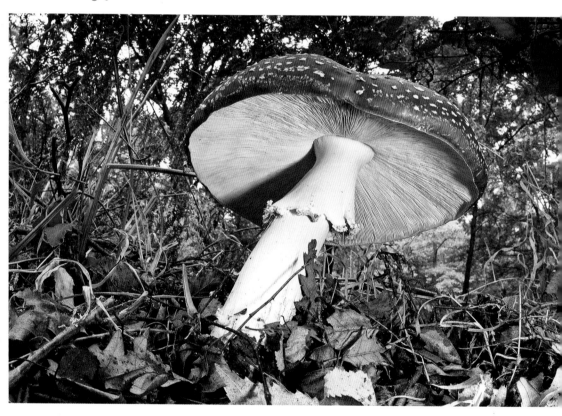

The best light for photographing fungi like this photogenic Amanita muscaria is usually ambient light using long exposures with the camera on a sturdy tripod. Here, however, a flash unit was employed off-camera to throw some light underneath the cap of the fungus and light the gills.

Many cameras let you mix flash with natural light. You can use DTTL flash control to properly expose your subject while adjusting shutter speed and aperture to expose the background correctly with the camera set to Manual exposure mode. In addition, some cameras have a Slow-sync flash mode that keeps the shutter open long enough to expose background properly when the flash is in use.

Reduce hot spots: Many leaf surfaces, stems, flower petals, and insects (beetles in particular) have hard surface coatings that reflect light—especially flash—and create specular reflections. A diffuser on the flash can certainly minimize these, but you will have to experiment with the angle of light to eliminate the glare, and maybe even work a little wizardry with your image-processing software.

One solution is a portable lighting tent that can be placed over your subject and lit from outside, though this restricts the background area and the tent can intrude into the picture when you use wide-angle lenses.

Ring flash units: Ring units produce soft, shadowless lighting, while available accessories can turn a typical flash unit into a ring flash by employing a circular reflector. Ring flashes can be modified by covering portions with black electrical tape to simulate two different-sized lamps (main and fill) to produce shadows that emphasize shape and texture (modeling) for photographers who prefer to capture a bit more color and contrast.

Twin tubes: Some macro flash units look similar to ring flashes but have two separate light tubes, or twin heads, that allow various power ratios between the lights. This can either offer the typical softness produced by ring units (when the tubes are set to equal powers), or create shadows to emphasize shape and texture when the heads are set to different strengths (up to a range of about three stops). Most units of this sort have only a modest power output and work best at close-range with

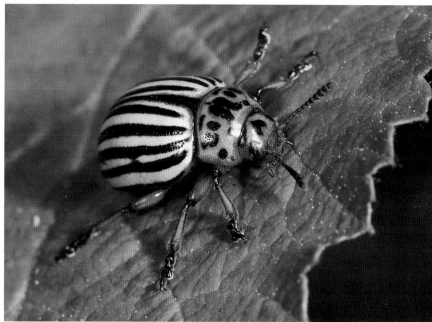

This Colorado Beetle has a hard surface coating that reflects light. There are still hot spots from the flash even though a diffuser was used. Daylight with light cloud cover would be a better light source.

either 50mm or 105mm macro lenses. One tube acts as the main light and the other the fill light. With longer lenses, the light appears flatter because the flash tubes sit too close to the optical axis to create much shadow relief.

True macro: A single handheld flash unit can be used to record true macro shots (larger than life-size). At close quarters, a small flash acts like a larger one when used with a diffuser or umbrella, creating a pool of light on the subject. A white card placed on the opposite side reflects light to fill shadows (if any). With DTTL, the length of the cable affects the response time, so you might have to experiment with the compensation buttons to get correct exposure.

Ghosting: This effect occurs when the flash freezes the subject but the camera shutter remains open long enough for ambient light to expose movement and create a ghost image. However, not all blur is bad—a blur at wing edges, for example, suggests movement and can enhance a shot.

Should I buy a macro flash unit?

Commercial flash units for macro work are expensive niche items, whether with separate twin heads, with twin tubes in a single unit fitting around a lens, or a conventional ring flash. However, they offer convenience because they are easy to use and deliver repeated exposure accuracy as well as consistency from one shot to the next. I would recommend these flash units if macro photography is important to you.

Some brands, such as Nikon and Canon, form part of a comprehensive lighting system that permits wireless control of several, separate groups of flash units. Wireless units made by independent companies work via a transmitter that fits in the DSLR hot shoe and uses its DTTL system to control various remote flashes. You can easily create an outdoor studio with a range of different flash units (e.g. a macro flash with an additional separate flash illuminating the background or angled to provide backlighting).

There are some definite advantages to a macro flash unit, be it standalone or part of a system. Flash is versatile because you can use it in the field or in a studio. Practice makes perfect, and with a bit of experience it is

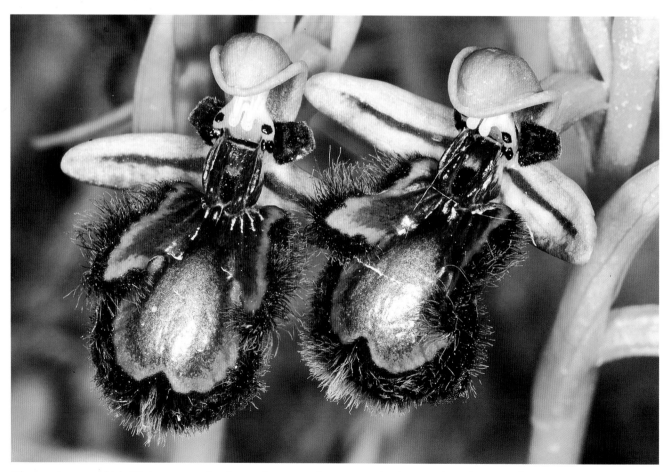

These mirror orchids (Ophrys speculum) were just two of many species I wanted to photograph on a Mediterranean hillside. A macro flash unit helped me get numerous well-exposed close-ups in a short time frame.

possible to quickly achieve that "point-and-shoot capability" where you can wander in a species-rich meadow and capture images consistently. When you want to change aperture to control depth of field, the system compensates, and you can do this without lifting your head from the viewfinder.

Additionally, a macro flash setup can be employed with an array of macro lenses (or zooms with a macro facility) from a focal length range of 50 – 200mm. A tripod becomes less than necessary to carry out to the field if your camera has a high-speed sync function—you could use 1/500 second as long as your flash has the power to illuminate the scene. The camera and flash can be set on top of a backpack, a minipod, a beanbag, log, or stone, or even handheld at that speed. If you wanted to mix daylight with flash, you would have to raise the ISO rating since less light enters the camera at high shutter speeds (unless the lens aperture is open quite wide).

You can also use diffusers with macro flash units attached to your lens to eliminate hot spots. Choose a wireless setup if at all possible. They make the unit clumsy, and there are horror stories of cables catching on branches and damaging cameras irreparably.

Different Flash Modes

Front-curtain sync is the usual mode. The flash is triggered just as the front shutter curtain is fully opened. With a moving subject and sufficient ambient light levels, this creates a ghost (see page 65) that appears in front of the flash exposure.

Rear-curtain sync means that the front curtain opens to start the exposure and the flash triggers just as the second curtain begins to close. There is a ghost exposure with a moving subject, but this time it creates

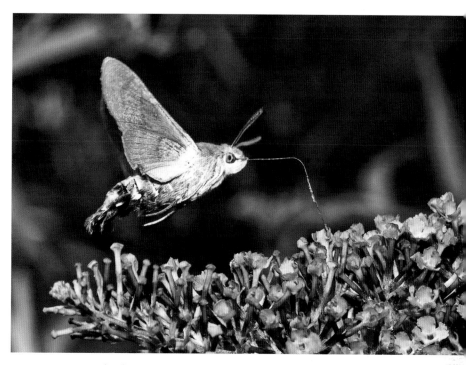

This hummingbird hawk moth (Macroglossum stellatarum) was caught in flight using the higher sync speed some cameras allow—in this case 1/320 second, which is fast enough to allow you to handhold and move in to get the shot.

a trail behind the subject that can accentuate the sensation of movement in an image. This mode can also be used to counteract shutter bounce in high magnification shots, because the flash fires after the shutter movement has been damped if the shutter speed is a few seconds.

Slow synch is good for low light or night situations when the shutter needs to be left open to capture ambient light metered by the camera while the flash illuminates the main subject.

The FP (focal plane) mode (built into many Nikon DSLRs for example) permits shutter speeds faster than the maximum sync speed of 1/250 second by effectively lengthening the flash pulse so that the subject is illuminated for the full time that the shutter curtains are traveling across the sensor. The flash intensity is reduced, but is more than adequate for close shots of insects in flight.

Can I put together a DIY macro flash?

It does not take a large workshop or an inordinate amount of craft skill to built your own macro flash units. You can use small yet powerful accessory flashes that are less expensive than macro flash units from major manufacturers. They are more versatile as well, since the lights can be fastened to extended arms via supplementary shoes (available at accessory suppliers) that are held away from the lens axis and, if you choose, can be fitted with a diffuser.

Two small flash units will be sufficient because you do not need excessive power when working close to the subject. Power comes from the flash batteries in the units, which can be connected to the camera by accessory cables. Wireless control is even better because trailing cables seem to have an uncanny attraction for branches and twigs as you hurtle through the underbrush, oblivious to everything but that rare butterfly. They are available for flash units that have wireless connectivity by using accessory controllers

A twin flash unit designed for film and fixed to the lens front of my DSLR was used to illuminate this colorful beetle against a light background. Several test shots were taken to obtain the optimal flash power and aperture settings.

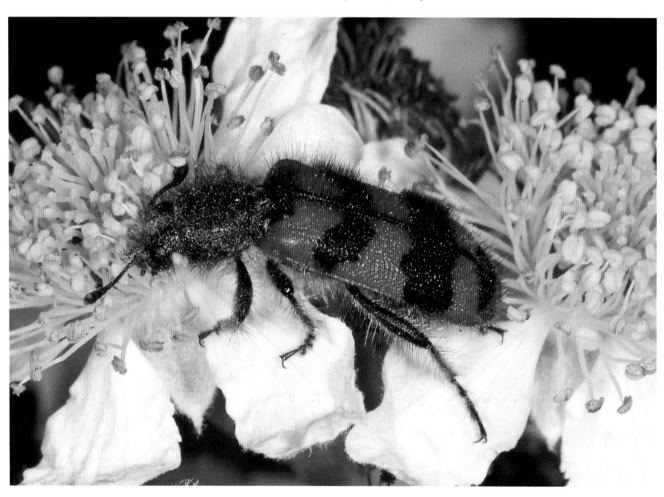

Since conventional macro flash units are low-powered, you might not be able to get close enough to light skittish subjects like his scarce swallowtail (Iphiclides podalirius). The solution is a diffused conventional off-camera flash unit; one that works with your camera's DTTL system is ideal, but a manual flash can be used if that is all you have.

that fit your camera's hot shoe. With manufacturers' macro flash units, the DTTL flash function helps control exposure, but you can make well-lit photos without it.

There are very good commercial flash brackets available from Novoflex, Custom Brackets, Really Right Stuff, and Manfrotto, among others. And, of course, there is George Lepp's, eponymous Stroboframe LEPP II Camera/Flash. You can also buy flash shoes to hold the flash units off camera, and many hardware stores sell aluminum alloy rods and sections—at most you just might need to be to drill a few holes and secure a few bolts or screws.

Don't necessarily discard old TTL and manual flash units. Even thought this is the digital age, you can still use them. Calibrate settings by reviewing images in the LCD to make adjustments so the exposure is correct in subsequent recordings. It takes a couple of shots to experiment and readjust by moving the flash unit and changing the lens aperture as required, but after a while you get to know what works and can make the proper settings before shooting.

However, before trying this, contact a photo dealer, manufacturer, or look online to ensure compatibility issues. Old flash units could blow a DSLR's electronics, so don't connect directly. If necessary, look into using your built-in flash to fire the older accessory flash via a small photoelectric trigger unit that fits the flash.

How can I get larger-than-life magnification on an image sensor?

The term "true macro" refers to images that are larger than life size (1x, 1:1) on a sensor (or film). It is possible to record subjects up to about 5x in the field, though it's a bit tricky to get sharp images. The depth of field is very small, and the slightest camera vibration or subject movement is like an earthquake. It takes a bit of thought, patience, and persistence, but when you are successful it is well worth the effort.

You can enter the realm of "larger than life" magnification either at modest cost using diopters, reversing rings, and coupling lenses, or with a fat wallet to buy brand name, true macro lenses and a bellows

accessory, if you can find them. Frankly, there is little discernible difference in image results from the two options.

APS-C DSLRs confer an advantage with macro work beyond life size because of the crop factor (see page 15). Using a macro lens and 1.5x multiplier/converter, you can fill the viewfinder with subjects that would require over 2x magnification on 35mm film (or FX). This setup is portable and fast in the field.

A 1.4x teleconverter added to a macro lens produces a boost in magnification that made it possible to capture the structure of this Zucchini flower.

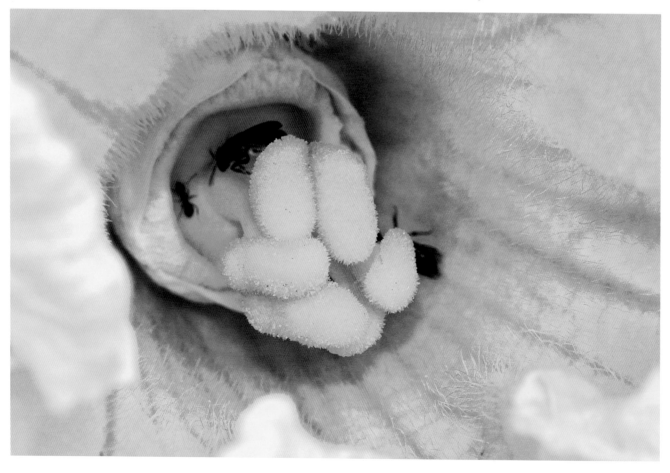

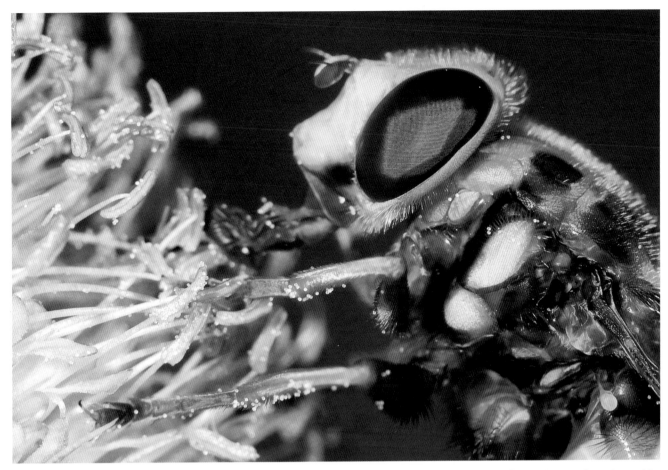

Normally it is hard to get this close to hoverflies since they are very active, but I chose a cool morning and used an old 50mm prime lens stacked on a 105mm macro to give just over 2x life size magnification on the sensor.

There are basically two practical methods for getting larger than life images projected onto a camera sensor (for best quality when magnifying images, it is a good idea to use sturdy camera and/or lens supports):

1. Adding another lens to the front of the camera lens. This includes the addition of a supplementary close-up lens. You can also use the same principle by reversing a second lens of shorter focal length and attaching it to the primary camera lens using threaded adapter rings.

2. Adding space between the camera and its lens. This involves the use of an extension tube, bellows, or teleconverter (multiplier). For higher magnification, you can try reversing a lens (see page 76) onto your camera. Though you lose electronic coupling advantages (auto focus, for example), you will get better optical correction. Reversing a lens requires an adapter/coupler called a reversing ring that has a filter thread on one side and a lens mount on the other. Beware of cheap items that are not well engineered because they can damage your lens mount—it is best to get the camera manufacturer's accessory or one from Novoflex.

How effective are supplementary lenses?

Supplementary lenses provide a good first route for recording close-ups without the purchase of a much more expensive macro lens. They are also called diopters, which is a misnomer, because diopter is really a measure of lens strength, not a lens itself. Supplementary lenses are often sold in kits with strengths delineated as +1, +2, +3, and/or +4, and are easy to use because they simply screw into the threaded filter holder at the front of the camera's attached lens. To determine the focal length (in meters) of one of these, use the reciprocal of its delineation, so that +3 has a focal length of one-third of a meter (333.33 millimeters). A new range of highly corrected supplementary lenses has appeared with items from Raynox and Micro Tech Lab that provide a convenient and effective way of getting up to 3x life size.

There is no loss of light with a supplementary lens, so adding one will not alter the effective aperture you set on the lens diaphragm. However, spherical aberration created by reflection between the surfaces of the supplementary and primary lens can lead to soft images at wide apertures; results are greatly improved by stopping down the camera lens to use light rays near its center.

This tiny tree frog (Hyla arborea) was photographed using a 105mm macro lens fitted with an achromatic close-up lens..

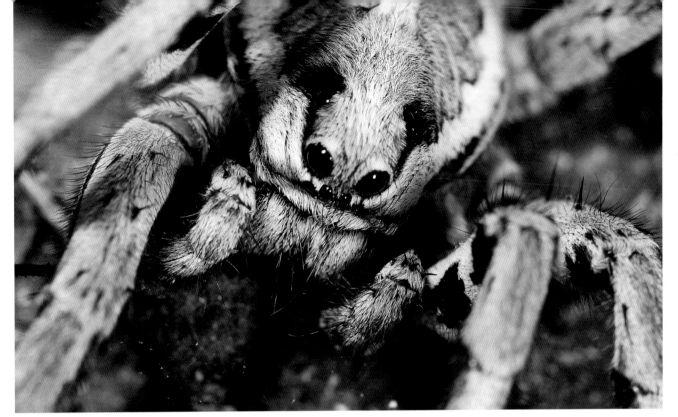

In addition to these simple supplementary lenses, you spend considerably more money for close-up lenses with two elements (achromats) made from two different glass types cemented together to eliminate chromatic aberration (the color fringing at edges produced by simple lenses). These work very well, particularly with zooms.

Figuring Magnification When Using Supplementary Lenses

The following useful formula works with all kinds of supplementary lenses, including stacked lenses (see page 78):

Magnification = focal length of primary (set to infinity) ÷ focal length of supplementary

Lenses such as the +1, +2, and +3 above are close-up lenses (as opposed to macro lenses). A +1 used with a 200mm telephoto lens set to infinity would give 1/5 life-size magnification (200mm/1000mm= 0.2x). Similarly, a +3 used with a 200mm telephoto lens on infinity would give nearly a 2/3 life-size magnification (200mm/333.3mm = 0.60x). The magnification increases when the lens is set at its closest focus.

When traveling light on a hike, a supplementary lens is excellent for giving a slight boost to magnification, as I discovered during a confrontation with a European tarantula.

This hanging alpine clematis (Clematis alpina) was just out of my reach, so a combination of a zoom lens plus a supplementary lens was needed to get the picture.

Do you recommend live view?

Nearly all digital cameras, including DSLRs, feature the ability to see a scene in real time on the LCD screen. This live view function can be useful for close-up photography. For example, when using the stop down (depth-of-field preview) function to check depth of field, the viewfinder image is often quite dark. Live view can magnify and intensify the image in the LCD to keep the scene bright and visible.

Live view works best with static subjects where you fix the camera to a sturdy tripod. Focusing is best done manually since there is a delay while the camera changes modes, and autofocus often has to hunt for focus when shooting close-up. With a high-resolution screen, the camera's live view function can zoom in on a subject so that precise manual focusing can be more easily achieved.

Live view coupled with a foldout and rotatable LCD allows you to get a worm's-eye view of subjects that are close to the ground, providing pictures with greater-than-normal impact thanks to the unusual perspective. Using live view and a camera tethered to a computer allows you to view the scene on a large screen for fine

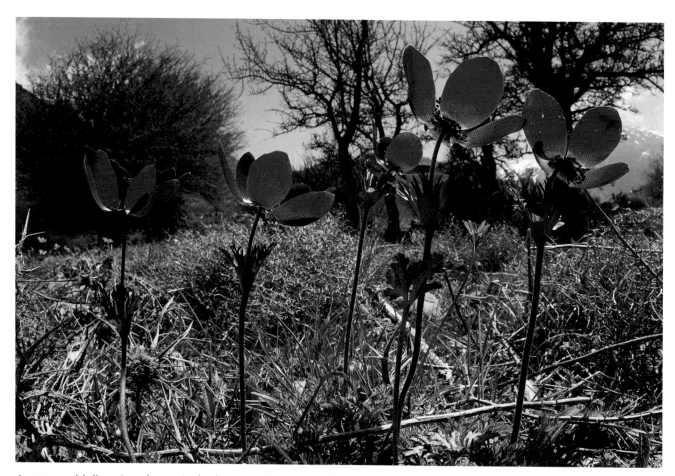

A screen with live view that swivels eliminates the need to lie in thorn bushes to take a photograph from below. A right-angled viewfinder is a useful accessory (but not as versatile) for those without such an LCD.

focusing with high magnification macro work—much easier than looking through the camera's viewfinder. This is very useful when creating image stacks to get extended depth of field and using your computer to control a camera via Helicon Remote (see page 89). In fact, the ability to control a camera remotely is possible from a laptop or iBook, via apps already on the market. This opens up possibilities with sensitive subjects and a whole range of triggered applications.

For those using bellows or an attachment to a microscope for high-magnification work, live view magnified on the LCD or rendered on a computer screen can greatly increase the proportion of ultra-sharp shots, especially for those of us whose eyesight isn't what it used to be in our younger days. However, there are challenges for the close-up photographer when it comes to live view. The delay in switching modes on DSLRs means that agile subjects may be out of frame before you record the picture. Sunny conditions in the field can also be frustrating because the brightness makes it difficult to see the LCD (though a hood is useful in those situations if you care to carry one). Also, regular use of live view will quickly exhaust batteries—I often work on a bench in the garden with both laptop and camera connected to AC power adapters.

Live view is not particularly useful for active insects because of the time delay between pressing the shutter and recording the picture, though it is definitely usable for creatures that won't move very quickly like this emperor moth caterpillar (Saturnia pavoniella).

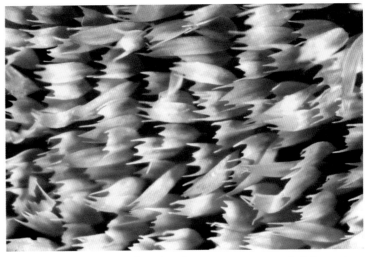

Live view usually has a function that can generate a bright and enlarged display on the LCD. This enables precise focus when working at high magnifications with lenses that do not have an automatic diaphragm and must be stopped down manually, therefore producing a dark scene in the optical viewfinder.

What is "reversing a lens?"

Reversing a lens literally means turning it around and mounting it backwards so that its front is coupled to your camera. To do this, you need a reverse adapter (coupling) ring. This process can be used to get high magnifications, especially from wide-angle lenses.

microprocessor circuits in the lens. This mode depends on being able to close the lens diaphragm, which is easy to do with mechanical diaphragms and a rotating aperture ring on older legacy (film camera) lenses. Search online to find an adapter from your camera manufacturer that fits to the end of the lens and allows it to be stopped down—they may be called Z-rings or reverse coupling adapters. Instead of using the lens ring to focus, you move the camera and lens setup in relation to the subject, or you can fix the setup to a tripod and move your subject instead.

The feathered antennae on this emperor moth, revealed by using a 50mm macro lens reversed on a bellows, have the ability to detect the scent of a female from a distance of a quarter to a half mile.

Reversing a lens leads to the loss of electronic communications with the camera, which means you will not have autofocus and metering capability. However, autofocus can be more of a hindrance than asset in macro work, and many cameras have a stopped-down exposure mode when set to Manual focus—they read the light hitting the sensor without information from the

Despite these disadvantages, reversing a lens can give much higher magnification than 1:1 when using lenses you already own, without the expense of purchasing a macro or true macro lens. This method works well with prime lenses, though success with zooms depends on lens design. Generally, the more ambitious the zoom range, the less likely it will work (e.g. a 35-70mm zoom would be more successful than a 28-200m zoom).

Reversing makes the most difference with non-symmetric lens designs where front and back lens elements have different diameters (wide-angle lenses, for example). Even reversed 1:1 macro lenses can show a distinct improvement in optical performance when used at 2x and greater magnification.

The first larger-than-life shots I took were with a macro lens reversed on a bellows. Here a 24mm f/2.8 lens stopped down to f/5.6 (effective aperture about f/32) has been used to capture the scale pattern of this butterfly wing.

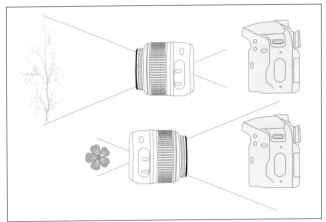

When a lens is mounted normally, the real life subject is usually at least 10 times larger than its image on the sensor. In the macro world, however, the image on the sensor is the same size or larger than the subject. Reversing the lens places the largest lens surface closer to the sensor, switching the optical arrangement and magnifying the subject.

Reversed Lenses with a Bellows or Extension Tube

You can also reverse a lens directly onto an extension tube or bellows. Bellows area bit clumsy in the field, but using them with a reversed lens produces enlarged magnification as long as you take every precaution to cut vibration. They attach to your camera body just as a lens would, and they have a mount for the lens on the other side. Most permit only a rudimentary ability to close down the lens aperture because electronic communication between lens and camera is interrupted.

Lenses with a rotating aperture ring are the best ones to use because an electronically operated diaphragm cannot be controlled from the camera when a lens is reversed. It can therefore be difficult, if not impossible, to adjust the aperture on electronically operated lenses.

When using reversed lenses, the aperture that actually records the image—the effective aperture—is not the one marked on the diaphragm ring because light spreads out due to the distance between the sensor and the lens. The effective aperture is the marked aperture plus a correction, depending on the magnification of

the system (see page 142). As an approximate rule of thumb, I find it is better to keep the effective aperture around f/16 – f/20. So, working backwards, divide 16 (or 20) by the magnification to determine roughly the f/stop you want to set.

What Lenses Can I Use with a Bellows?

It can't hurt to try reversing any lens. Experimenting is a good thing. Some zooms will be effective, but most will not. However, lenses such as wide-angle primes, large-format, and those for darkroom enlargers can work very well for macro shots. Old 16mm cine lenses, such as the Switars (25mm) made for Bolex cameras, are incredible as high-power macro lenses when reversed with a bellows.

You can also use true macro lenses. These have no internal focus mechanism and are designed towork within a specified magnification range when mounted on a bellows (e.g. 2x – 6x, 4x – 12x). Though relatively expensive, these have been issued by manufacturers such as Olympus, Leitz, and Zeiss for use with specific ranges of magnification.

What does it mean to stack lenses?

Lens stacking is reversing a photographic lens (as explained in the previous question) and attaching it to the front of another lens of longer focal length, usually a telephoto of 100–200mm. It affords one of the best ways of producing larger-than-life-size images (optically and cost-wise) by using a wide-angle or standard lens of a single focal length (prime) that you may already own.

One popular combination is to reverse a standard prime lens (approximately 50mm) and attach it to the front of a macro or medium telephoto lens using a male-male thread adapter. Again, such adapter accessories for reversing lenses are available at full-service photo resellers. In this role, the reversed prime acts as a high quality supplementary lens—a 50mm has a 20 diopter (20D) strength, while a 24mm boasts more than a 40D strength. Stacking like this is a great way of using legacy prime lenses that were originally purchased for film SLRs.

The magnification (M) you obtain from the combined lenses is given by the formula:

M = focal length of camera lens ÷ focal length of stacked (supplementary) lens

This holds when both lenses are prime and set to infinity—focusing closer using the camera lens increases the magnification slightly. For example, attaching reversed lenses of 50mm, 35mm, 28mm, or 24mm to the affixed lens of 105mm focal length, you'll get magnifications of 2.1x, 3x, 3.75x and 4.4x respectively. If using a 150mm lens attached to your camera, the magnifications when stacking would be 3x, 4.3x, 5.4x, and 6.3x. The wider the maximum aperture of the reversed lens, the easier the focusing. The formula also works at different focal lengths when a zoom lens is fitted to the camera.

There are several factors to consider when stacking lenses:

- Vignetting is possible and more likely with a full frame sensor and a reversed short focal length lens, especially if there is a big difference between the front lens diameters where the two lenses are coupled. One possible way to correct this situation is to add an extension tube to the setup, which allows light rays to spread out when striking the sensor.

Depth of field is always restricted when working at reproduction ratios greater than 1:1 (life-size). The art is selecting exactly those parts you want in focus, and the choice in this picture was the yellow stamens of the flower.

- When using a telephoto zoom lens attached to your camera, stacking functions best at the long end of the zoom that has limited range, such as 100mm – 200mm (mid to longer focal lengths), but the quality of your results will depend on the zoom design. You need to experiment.

Sometimes when you couple lenses, there is a mismatch between their front diameters, especially with wide-angles. The result is vignetting, which produces a reduced visual field where image edges are cut off. Stopping down the lens nearest the camera is the best way to ameliorate this effect.

- Wide-angle zooms attached to the camera tend not to work well when coupled to a reversed prime lens, but they can be reversed onto a bellows.

- Depending on the aperture used, the autofocus function is often better switched off in macro work to prevent it from hunting, which at greater magnifications would make focusing impossible.

- TTL exposure control can still work when the aperture is controlled from the lens closest to the camera since the lens is coupled to the camera system.

- Whenever you deal with magnified images, light is said to be lost because it spreads out over a larger area, resulting in a reduction in light intensity at the sensor. Most modern lenses (especially wide-angle lenses) are asymmetric in design, with front elements considerably bigger in area than their rear elements. The light-gathering power of such lenses is reduced as the smaller lens element faces outward, and the effective aperture is lower than the one marked on the lens.

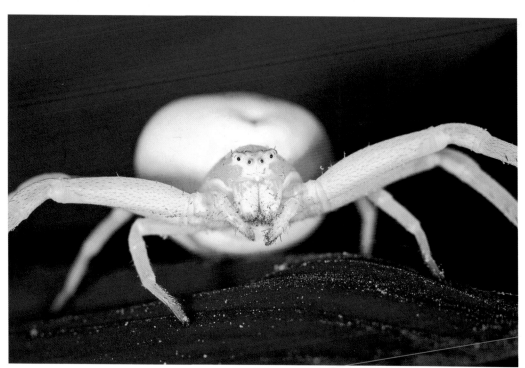

It is hard to hold stacked lenses steady, and the slightest vibration is exaggerated with such setups. However, resting the lens combination on a bean bag when recording an accommodating subject will give you very sharp shots of small creatures, such as this crab spider (Thomisus onustus).

Which aperture do I adjust with stacked lenses?

There are two diaphragms involved when stacking lenses—one is the front reversed lens, and the other is the prime lens that is fixed to the camera. The question is which do you adjust, and why? A theoretical treatment and full analysis is beyond the scope of this book, but fortunately, experiment and experience comes to the rescue and suggests the following:

• Stop down the reversed front lens to around f/4 – f/5.6 (if it has a manual aperture ring). This is to optimize performance with a lens of large maximum aperture, and to reduce spherical aberration from the edges of the lens element with the larger diameter.

Where there is no aperture ring, use the front lens with the aperture wide open, or employ a Z-ring that allows you to close the diaphragm with a cable release. These types of rings can often be found tucked away in manufacturers' accessory lists (e.g., Nikon BR-6 auto ring).

• Everything else is done from the prime lens coupled to the camera, and the camera itself can be used to control exposure with its DTTL flash system. Check in the viewfinder to see when vignetting becomes apparent as you close the diaphragm. This provides a limited range of useable apertures up to the point on the lens where you notice darkening of the image field's edges. Remember, the effective aperture is not the one marked on the lens coupled to the camera. Work out the magnification as described in the previous question and look at the table on page 142 to determine the effective aperture. Keep the effective aperture to a maximum of f/22 or less to minimize diffraction softening.

• Connect an extension tube between the camera body and the prime lens to spread the light rays if vignetting occurs, which is possible if there is a relatively wide discrepancy in diameters of the front and back elements of the reversed lens.

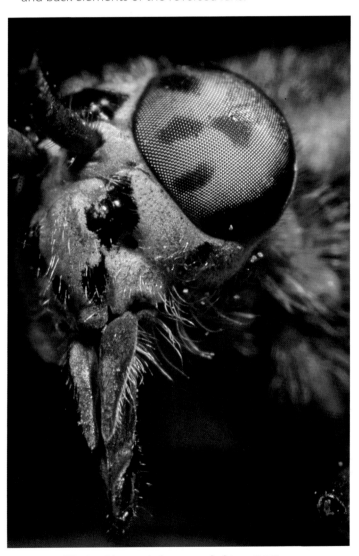

A 24mm f/2.8 wide-angle lens coupled to a 105mm macro gave just over 4x magnification in this shot of a horsefly's eye. The stacked lens setup was supported by a beanbag, and it helped that the insect, though alive, was trapped in a spider's web.

Where can I get adapters for lens coupling?

One reliable place to purchase the types of adapters and couplings needed for close-up and macro work is The SRB-Griturn Factory Shop. They are engineers who supply worldwide and are able to make anything you want. Have a look at the close-up section on their website where you can buy the appropriate coupling rings (male thread to male thread). I suggest that you get a 72mm to 72mm (or 62 to 62mm, which is a Nikon standard) and then use stepping rings to fit to the lens (or lenses) you want to reverse. They also make T-mounts—standard lens mounts—that can be screwed together to make adapters

You can make your own if you can find a couple of Cokin filter adapter rings or second-hand filters and remove the glass. Here is the method:

- Degrease them by washing in mild detergent and allow to dry. Then prepare the flat surfaces for the application of a super glue type of product by rubbing with a fine, 400-grit emery cloth.

- Try a dry run. Adhesives like super glue are unforgiving, and you get little time to fiddle. To experiment without permanently bonding the pieces of adapter rings, you can always try black insulation tape around the rims.

- Mate the large, flat surfaces of the two adapter rings with super glue (or a similar product, keeping your fingers clear, of course!) Do this well away from any lens, since cyanoacrylate (super glue) smears would be a disaster. You can also try other commonly sold adhesives to see what works.

- If, like me, you worry about the glue joint splitting and a lens falling off, you can drill a few small holes around the cemented adapters and use small self-tapping screws.

A friend gave me a box of ancient microscope slides including one that had a piece of coral mounted on it. I made an adapter to fit a 10x microscope lens to a Nikon bellows. I used a T-mount to make a suitable adapter and get a magnification of about 25x.

I made this coupling adapter from two separate rings that were originally for the Cokin filter system—a 67mm fitting on one side of the adapter to match the macro lens on the left, and 55mm on its flip side (with a 55mm to 52mm reducing ring) to fit the lens on the right. I cut the bottom out of the rear lens cap on the right to create a hood when that lens is reversed.

How can I be sure to get sharp macro images?

As mentioned, a magnification greater than 5x is not practical in the field because of the exaggerated effects of camera movement. So macro photography, especially with stacked lenses, does not always lead to the sharpest of images without enlisting techniques to minimize blur. It is best to switch off the autofocus and to focus manually, by either moving the camera and lens in relation to your subject, or by moving the subject closer or farther from the lens. I find it most useful to work with a 105mm macro or a 135mm telephoto (or tele-zoom) attached to the camera with a stacked 50mm lens to produce 2x images.

Trying to follow action and find the subject with a stacked system is often a challenge, but the result is worth it. When photographing moving creatures, such as ants on a stem, prefocus on a spot ahead of the action. Use a cable or wireless release to trigger the camera when the creature arrives at the point of focus.

In addition, various tools can be used to support your camera. A beanbag is one of the most effective for field conditions, absorbing vibrations while being convenient both for placing your camera at ground level or on a stone wall or log. A small, rigid tripod can work well, just use care not to produce vibrations with your hands.

I have been experimenting with a simple optical bench for field use, particularly when I want to record a series of stacked images. Camera and subject are fixed to a rigid alloy bar with a hole drilled at both ends to fix a quick mount and a focus slide. It can be screwed to a sturdy tripod via a mounting hole drilled and tapped on the underside.

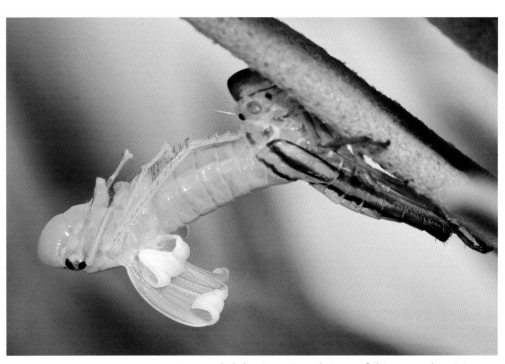

I recorded the tiny winged stage of this sapsucker (Cicadella viridis) as it emerged from its previous existence.

Studio and Tabletop Setups

You can create a simple studio by mounting the camera on a solid table. I set up a small stand with crocodile clips to hold the subject (an insect or twig). With the camera steadily fixed, my hands are free to move the subject closer or farther away to the camera. Check the focus while this is happening by looking through the viewfinder, or use a right-angled finder if it gives a more comfortable viewing position.

The idea for this type of studio, illustrated in the top photo below, came from an optics lab I was once associated with where a rigid support allowed photographers to move camera and subject along the same rail. I used a 1.5-inch (3.8 cm) square alloy bar with sides on it, creating a channel in which other bits of square section bar could slide. The sides were fixed to the square bar by drilling carefully through all the alloy

My homemade studio setup is basically a heavy bar with camera plus bellows at one end and the subject held at the other with crocodile clips, separated by a channel within which either camera or subject can slide back and forth.

Precise focus using this do-it-yourself macro-scope is achieved by moving the bellows rail on its vertical rack. This is a very efficient use of space, as it can sit next to a computer and be coupled to it if I want to focus on screen via live view.

material into the bar and tapping a screw thread so they could be bolted together. The camera is fixed to an Olympus bellows with homemade adaptors to fit Nikon or Sigma bodies. The camera and bellows are bolted to a sliding rail, while the subject is mounted on a small platform fixed to a focusing rail. For high-magnification photography, everything can be screwed down rigidly.

Focusing

Camera and subject movement must be finely controlled with magnified images or the subject will become out of focus. Well-engineered focusing rails are reliable, but less expensive models can create a distinct wobble as you look through the viewfinder, and that will affect register with image stacking programs.

There is a choice between rack-and-pinion and lead screw type focusing rails. Quality-built rack-and-pinion models, such as those from Novoflex, are superb. The rack is cut diagonally and there is negligible backlash (tiny movement of the adjustment screw before it takes up the gearing and moves the subject/camera). Lead screws are more expensive because they include micrometer threads that move the camera with great precision (e.g. in steps of 1/100 mm). They can be driven by stepper motors, a great method for stacking shots with Helicon Remote, a utility that allows your computer to control lens focus.

A macroscope is basically a microscope stand fitted with a bellows. Mine, with the stand bought at a second-hand store, is compact and inspired by expensive commercial versions. I removed most of the unnecessary parts by taking out the mounting screws, and fit a Nikon bellows on the stand. The camera is fixed to the upper end of the bellows, with old microscope or other lenses fixed at the lower end via homemade adapters.

Do I always need a tripod?

When stalking butterflies and other small creatures, a tripod can be far from convenient to carry and set up. It is not always easy to place one as close as you want, and flailing tripod legs are guaranteed to scare your quarry.

But small apertures are often used in close-up photography in order to increase sharpness through longer depth of field, so relatively slow shutter speeds are needed to attain enough light to reach the sensor. Therefore, sturdy tripods are a valuable aid in producing sharp close-up photos. However, things are changing at the moment. Image stabilization features have become widespread among cameras and lenses, allowing pictures that are sharper than previously possible at slow shutter speeds. And the exceptional performance of many recent DSLRs at high ISO settings means that excellent low-light results are possible at fast shutter speeds. If your camera does not have particularly good lowlight performance, then using some type of stabilization (with natural light) or relying on flash (so fast it freezes movement) is best to ensure image sharpness.

When shopping for a tripod, buy the best, most rigid one you can afford; a flimsy one is a waste of money. It doesn't have to be heavy, it can be made from carbon fiber, but that comes at a high price. There are some good small tripods available that hold the camera plus lens and accessories firmly and close to the ground when you need those low shots. These can make life as a close-up photographer easier. There are also larger tripods with reversible central columns and legs that can be splayed so that you can lower them close to the ground.

You may be able to get away without a tripod by using a little ingenuity. For example, a backpack can effectively

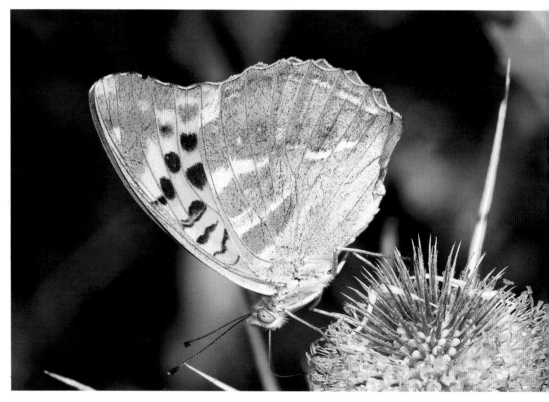

A tripod offers the best stability for your shots. Alternatives to avoid camera motion include using a high sync-speed with flash or ISO settings high enough to permit high shutter speeds, though you still may need some other type of support. For example, this silver-washed fritillary butterfly (Argynnis paphia) was taken using a monopod.

This is my minimalist set of accessories when photographing flowers and insects in mountains where a heavy rucksack is a killer. It involves two lenses (macro and ultra-wide), a macro flash setup, and a small Novoflex tripod to support it all.

absorb vibration and cut movement when you rest a camera on it. Even better is a beanbag type of device that you can purchase or make. A small cloth bag with a zipper filled with polystyrene beads, rice, beans, or even small pieces of dried pasta will work.

Monopods

A monopod fitted with a ball and socket head is a good option for close-up photography. You can approach your subject, assess its height, and let the monopod leg sections drop to touch the ground. Secure all the sections except the ball head until you are reasonably close—with the ball head loosened, you have the freedom to tilt the camera up or down, swing it sideways, and tilt the now rigid monopod. When you are where you want to be, tighten the head and shoot.

A backpack makes a serviceable support. When photographing close to the ground you may find yourself using rocks, a hat, or your camera bag—ingenuity always finds a way.

How can I shoot HDR close-ups?

HDR (high dynamic range) is a digital technique that is particularly popular with landscape photographers. It involves taking three or more exposures: one that the camera's meter indicates is "correct," one that will overexpose the scene by a stop, and one that underexposes the scene by a stop. The procedure is convenient with DSLRs because nearly all models have autoexposure bracketing and continuous shooting modes. The multiple exposed images are then combined using software to create a single high-dynamic-range image—one that extends the sensor's typical dynamic range from five stops to seven or more.

Used carefully, the HDR technique can produce superb results for stationary subjects such as landscapes, but it is not really appropriate when something (such as vegetation) might move even slightly between exposures. HDR draws fire from a number of critical photographers who claim there is an obviously artificial look to the results because they appear over-saturated with too much contrast. Those defects say more about photographers who espouse such over-cooked images;

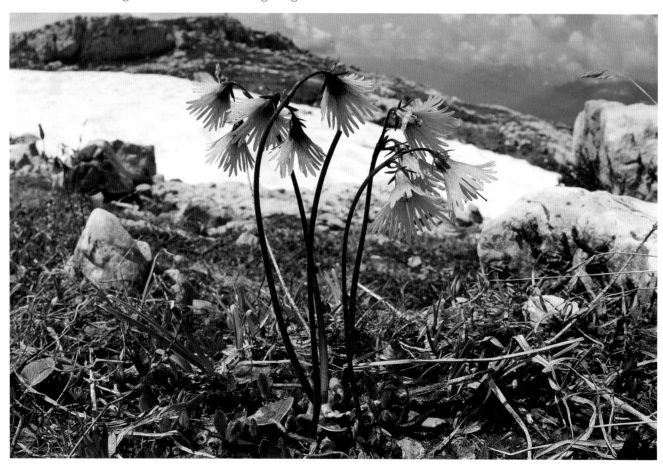

Including bright patches of snow in your close-up photos can challenge the dynamic range of your camera's sensor, as it cannot capture shadow detail without burning out highlights, or vice versa. The neutral density filter function in Adobe's Lightroom program can help ameliorate overexposed image areas without resorting to multiple exposures.

High in the mountains of Crete—and nowhere else in the world—grows a tiny tulip (Tulipa cretica). It has delicate pink tones on white and inhabits screes of serpentine rocks that are dark green—almost black. A sequence of under and overexposed images (as illustrated by the top and middle photos at right) can be combined in HDR software to capture the full range of tones in this scene (bottom right).

the art in utilizing HDR is to produce an image with a full tonal range that looks natural. There are many great examples that expand dynamic range without careening into a synthetic visual world.

HDR is most effective when recording stationary subjects, which in the close-up and macro realms might include lichen on rocks or perhaps a blossom when there is no breeze. Where it can function particularly well is when there are plants in the foreground of a landscape taken against a bright sky. It is possible to use fill flash in the foreground, though this can also produce a slightly artificial result when not used with care.

In one way, it is convenient to think of HDR as a sophisticated neutral density (ND) filter that reduces contrast in highlights and increases it in shadows without the straight-line cut-off of a conventional ND filter (and unlike an ND filter, you don't have to cart it around).

The automatic exposure bracketing feature and fast burst rates of today's DSLRs lead some photographers to record a series of images without using a tripod. However, a firm tripod is essential for HDR, as is patience to wait for still moments if there is any breeze. Slight camera movement may be correctable by the software that registers the images and creates a tone map, but absolute alignment among the images in a series is only assured with the use of image stabilization. A subject that moves in the breeze is a problem that has limited the use of HDR in close-up and macro photography, but the technique remains worth exploring.

HDR requires certain software programs to properly align and tone map the image files. Photomatix Pro (from HDRsoft) is favored by many, and Nik also has a popular program (HDR Efex Pro). Photoshop users can also merge exposures for HDR.

What is image stacking?

The perennial problem when trying to maximize depth of field in close-up and macro photography has always been the balancing act between trying to increase the field of sharpness by employing small apertures and the softening effect created by diffraction as the aperture gets smaller. However, with digital there is now a way to take a sequence of images (a stack) using a normal macro lens and combine them to create a single sharp image that possesses extreme depth of field.

The idea is to record a series of photographs with the lens set at its optimum aperture, known among photographers as the "sweet spot," usually found between f/5.6 and f/11. This is a wider aperture than you would normally use for maximum depth of field. You will want to shift the focus point by a tiny amount between each exposure of the series. This series of pictures is called a stack, and software programs such as Helicon Focus or Zerene, or even Photoshop, are used to process the image stack by creating maps that take the sharply focused bits from each frame and combine them to produce enhanced depth of field. Each program allows you to control the way the images are blended for best visual effect.

It is important to make sure there is no camera shake or movement of the subject that would upset the images' register (the capacity of all images in the stack to exactly correspond with each other). Though stacking programs try to cope with movement and create a best register of sequential frames, it is better to record the most static sequence of shots to begin with.

How Do I Change Focus?

1. Move the camera (or subject, if it is movable)

The best way to ensure sharp focus for stacking images is to use a focusing rail. This is a geared device upon which you mount your camera and lens. It allows you to adjust the camera's position in very fine and precise movements. Set the camera lens with the magnification you want by looking through the viewfinder or at the LCD screen. Live view and manual focus are useful with small subjects that are highly magnified.

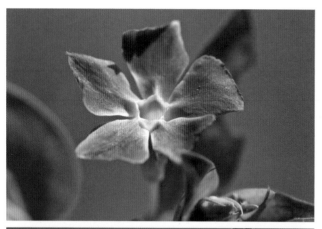

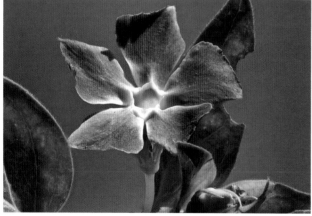

The upper image shows a photo from the middle of a stack. The lower is a composite of 28 shots produced using Helicon Focus, a program that allows you to combine a sequence of images, each recorded at slightly different focus points, into a single photo. The lens was at f/5.6 and shutter speed 1/500 second.

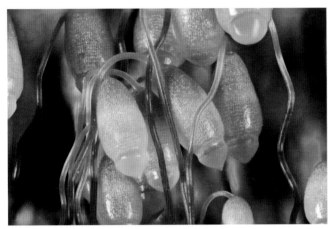

When stacking with Helicon and similar programs, you can tweak the composite image for final adjustments with sliders after the series of images has been mapped for sharpness.

Alter focus in increments from in front of the subject to behind it by moving the camera along the focusing rail. The rack-and-pinion mechanism of the slide should be smooth so that there is no lateral movement as the camera moves forward, or no backlash in the focus knobs. An old microscope stand can be modified for this purpose.

2. Using the focusing ring on the lens

When the lens is set to Manual focus, note the position of the focusing ring at the extreme ends of focus and then make uniform, small adjustments between those extremes. It will take a few practice rounds to figure this out because you need to become familiar with how many images are needed in a stack to produce an optimal final

image: too few, and the composite will not be smooth and will contain ghosting that appears at the edges of details.

Each step in altering the focus point as you record the separate images in the stack must be less than the depth of field in order to create sharpness overlap between successive images. As magnification increases from 1x, depth of field decreases, so changes between the focus points must get even closer together.

3. Controlling focus steps from a computer

Helicon Remote, a utility that works with selected Canon and Nikon DSLRs, allows your computer to control the lens focus while providing a live view on the computer screen. It lets you set the front and back limits of focus, and then calculates the number of steps required for the magnification and aperture in use. The process starts with release of the shutter from an on-screen command, and the series of exposures is made with the focus shifted slightly from one image to the next using the stepper motor that controls the lens autofocus (AF is disabled). The image sequence can then be exported directly to Helicon Focus for processing to a single image.

A focusing rail (seen here at the right side of the portable "optical bench") enables the fine precision needed to record a stack of images, allowing you to render a long depth of field in your macro shots.

Can I create image stacks in the field, or is stacking only for the studio?

The controlled process for focusing while recording a stack is easier in a studio using a focusing rail setup on a stable bar like my homemade optical bench (see page 89), but it is possible to do the same work work in the field. This will require wide apertures so shutter speeds can be fast enough (1/250 second or faster) to freeze camera shake or slight subject movement—movement within the scene will spoil the registration between the images in a stacked series. However, there are several points to keep in mind when attempting to record image stacks in the field:

- Turn autofocus off and focus manually.

- Set your camera on a firm tripod on a still day and fire it using a cable release.

- The stems of plants, though "elastic," do not always return to the exact same place between pictures when there is a breeze. A clear acrylic (Perspex) screen can be used to shield a plant or other subject.

- Flash is an option, but many insects flinch with flash and change position slightly from one frame to the next.

- There may be a significant delay when using a built-in or accessory flash that is not very powerful, due to their charging cycle. The flash must be at

the same power for each successive shot to have the same exposure. You may be able to adjust obvious discrepancies in Lightroom or Photoshop when you look at a stack before combining them.

- Please work with live creatures—they test your photographic skill and there are far too many pictures of insect corpses on the Internet from people unaware of just how obvious it looks to any naturalist.

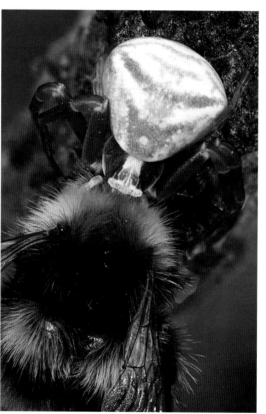

Crab spiders (Thomisus onustus) are some of the most obliging subjects in my garden because they stay still for long periods, awaiting prey. This one was hidden in a lavender bush when it captured a bumble bee. I used flash and an aperture of f/8 for a sequence of 9 shots.

An additional strategy is to take some studio equipment out to the field—even a laptop to control the camera via Helicon Remote, although that means more to carry. You can set up outdoors with flowers, or even insects on a piece of plant material on a calm day. Remember that the focus steps need to be very close together with highly magnified subjects; perhaps 20 or 30 in a stack with the focus shifted almost imperceptibly between shots because the depth of field is very small, and each step must be less than the depth of field.

To get an idea of the size of the steps between shots in the stack, examine the depth of field table (page 142) for Magnification (M) = 5x (for effective aperture of f/22, the depth of field is 0.36mm). A rack-and-pinion drive on a

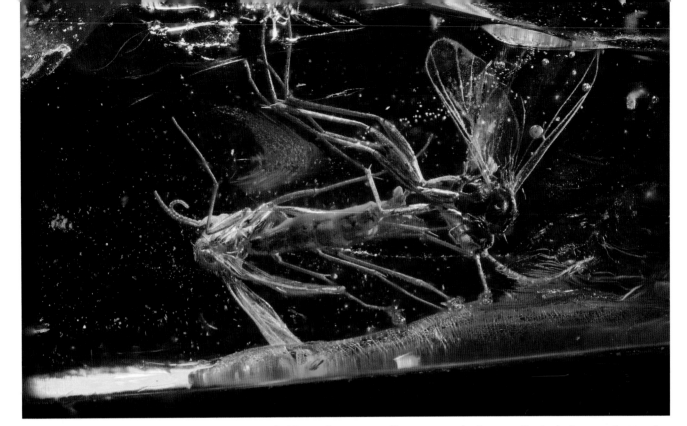

Though possible to record image stacks in the field, results are usually more precise in a studio. I tried many times using conventional methods to photograph this small piece of amber containing two prehistoric mosquitoes, but I could not get both insects in focus because they were trapped at different depths. I finally got both in focus by setting up in my home studio to create an image stack.

focusing rail is not always fine enough for this type of macro work. Focus slides that use a micrometer screw can do the trick and one, the Stackshot, can do this under control from Helicon Remote.

Sometimes individual images in the stack don't seem sharp. This often happens with magnified images, and there are two things to consider:

1. Vibration, which is caused not only from camera shake or subject movement, but also from the camera's mirror bounce (on DSLRs). Use your mirror lock function if you have one, even if it eliminates live view. You still cannot damp this vibration at higher magnifications, no matter how rigid the stand you use and the table it is on.

2. Diffraction softening, due to the dispersal of light rays as they travel through small apertures (see page 25). There is a marked or set aperture for a lens used with a bellows or tube (e.g. a reversed lens, a true

macro, a microscope lenses, or a macro such as Canon's MPE 60mm), but you have to consider the effective aperture because of the extension's effect on diffraction.

Suppose the lens is set to a marked aperture of f/8 and an extension is used to produce a magnification of 5x. That changes the light intensity by about 6 stops, so the aperture is now effectively f/45. Even opening the lens to f/4 produces an effective aperture of f/22 (see table on page 142). Any smaller and diffraction becomes obvious, although you can try sharpening the image (see page 138).

Stacking is not as confusing at it may sound. It works with incremental focusing changes to give very encouraging results. When you get hooked on this technique (and you will), you will strive for perfection.

Shooting in the Field

Master the basics and you'll find the only thing limiting your picture taking is imagination. This section contains many examples of things you can photograph outdoors—butterflies, raindrops, flower interiors, leaves, pond life—the possibilities are virtually endless.

Though this section is not exhaustive, its aim is to build your confidence as you go from absorbing and trying these techniques, to thinking about and composing your own images, until finally, you are flying free. Seeing everything around you in a new light adds to your list of subjects. This has been the guiding principle behind the hundreds of photography workshops I have run over the years, leading you to see everything around you in a new light and adding to your list of subjects.

Yes, there are challenges, because close-up work tests and develops all of your photographic skills. But what you learn can then be used in landscape and portrait photography, lighting large scenes, and beyond.

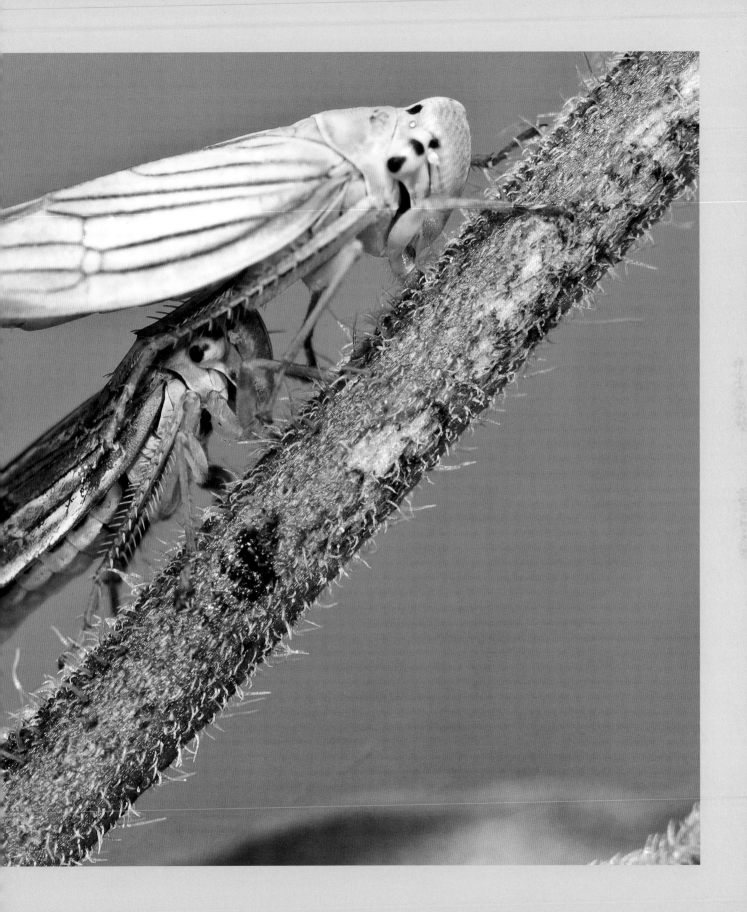

How do I manage my images while traveling?

It is a good idea to have a plan when setting out on a field trip, since a digital camera makes it extremely easy to accumulate lots of images and fill memory cards. This is especially true if using continuous shooting mode to capture a bee or butterfly in mid-flight about to land on a flower.

Instead of a very large-capacity memory card, I suggest carrying several cards of lesser capacity. If your single large card fails or is mislaid, you will lose all of your images. On the other hand, if your collection of recorded photos for a trip is spread over several cards, the loss of images on one card, while upsetting, is not a complete disaster.

However many cards you use, it is essential to routinely back up or download your image files at the end of every day in the field, or even every half a day. A laptop and iPad-type tablet is a useful device if your trip is more than a single day. Upon returning to a motel or base camp, the day's images can be downloaded via a card reader to your device and simultaneously backed-up to a portable hard drive. Additionally, though I advise against a single large-capacity memory card to record images with your camera, they are useful as an extra source of backup storage. Your pictures are now stored in three separate places if you keep the files on an extra memory card, a computer hard drive, and a portable hard drive. Keep these various storage libraries separate and the chance of losing any of your files is virtually nil.

I recommend a couple of additional practices to further manage your image files. On your laptop, import them into your image-processing program to view and make a preliminary edit by discarding those that are clearly unacceptable. On a 15-inch screen, you can quickly recognize the best images and use a star system to rate them. I have accompanied teachers with groups of schoolchildren on field trips to look at plants and small animals. After they have taken their images, it takes little more than 15 minutes to perform a quick edit and create a PDF slideshow in Lightroom to show them their beautiful handiwork.

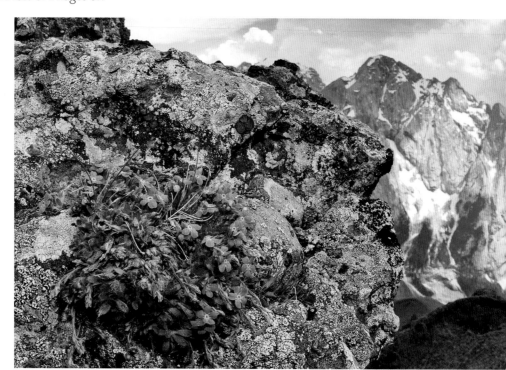

I recorded some 1500 images in just four days on a hiking trip to the Dolomites in Italy. All were stored on cards and downloaded to a laptop at the end of the day. I reformatted the cards for additional shooting only after back-up copies had been cut to a DVD or transferred to a second hard drive I brought along.

Where can I find exciting close-up images?

It is true that you may find more exotic photographic subjects if you travel to foreign lands than if you stay close to home. But the best way to perfect your technique is to practice. Digital photography is great for the way it affords instant feedback, allowing you to check a shot and change exposure, reframe, or refocus. This is an unrivalled way to learn and, with determination, you can enhance your proficiency as a photographer in all areas. You will want to become very familiar with your camera and ancillary photographic equipment so that it becomes almost second nature to use. This allows you to concentrate on making the picture.

In a flower bed just outside my back door a female glow-worm shone her abdominal light in the hope of attracting a winged male.

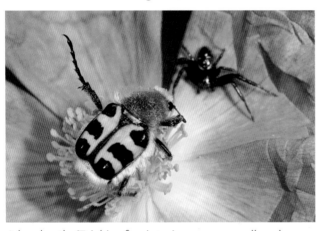

A bee beetle (Trichius fasciatus) warns a small crab spider by waving a leg—one of a myriad of events that occur in a typical day in any garden. I am amazed how many images I can obtain right outside my front door to illustrate articles and blog posts.

Clearly, you can practice more often and critique your work more thoroughly if you are close to home. Enhancing any skill set takes effort, but most hurdles can be negotiated with a little patience. Photographing in your backyard, in a nearby park or public garden, or in a regional nature reserve offers easy access, familiar territory, and makes it easier to persevere.

Wherever your location, whatever your facility to manipulate camera settings, the most important ability nature photographers possess is recognizing the picture in your mind's eye. A large part of successful macro work involves learning to see as a child, with wonder at the world's amazing details.

I live in an old Italian farmhouse where the countryside is rich in wildflowers, insect life, and songbirds. Realizing my good fortune, I keep a camera permanently ready so that natural life can be quickly photographed. Because of this, I have obtained large numbers of images. So yes, photographing close to home has been very productive. Aside from being more economical and environmentally friendly than traveling to glamorous photo locations, photographing close to home should not be considered second best, but valued because it is deeply satisfying and great fun.

You may not have tigers and crocodiles in your backyard (count yourself fortunate), but smaller creatures, when captured with your macro lens, can look like something out of science fiction and be far more fearsome.

Can I get outside shots in the winter?

You will find a shortage of subjects for outdoor close-up photography during the winter if you live where it gets cold, but you can always go on an adventure to search for primitive plants such as lichens, mosses, and liverworts. Winter and early spring are good times to photograph the natural mosaics made by different lichen species, which are slow-growing plants that encrust rocks and old tree bark. I tend to go out on a clear day into the fields and woods to photograph these plants in late afternoon light, where the low sun position provides side lighting and casts shadows, creating relief that enhances the appearance of sharpness. It helps to utilize some type of camera support (tripod, monopod, beanbag, or perhaps leaning against a stump or wall).

Mosses, found in damp, shady environments, are interesting because they provide micro gardens that can be explored with a variety of close-up techniques, from habitat shots with wide angles to higher magnifications in the macro realm. Additionally, they are good subjects on which to practice stacking techniques (see page 88). At a level closer to microscope work, you will find that a whole range of tiny specialized animals live in mosses.

When working in the cold, flash and camera batteries will run down much more quickly than normal, so keep a set of charged spares warm in pockets close to your body. Rather than separate cells, some photographers use a battery pack that is kept warm under a jacket or in a pocket and is connected to the camera with a small cord.

Hands can become cold when photographing mosses outside in cold climates, causing dropped lenses and other accessories. So even though gloves may feel clumsy, I suggest wearing them until it is time to change your lens or attach a filter or flash.

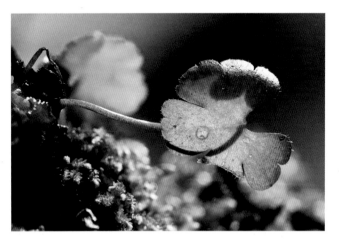

This leaf of Herb Robert (Geranium robertianum), a tiny wild geranium that grew in a cushion of moss, was beautifully displayed due to the angle of the backlight on a bitterly cold January.

These highly reflective goblin's gold moss plants look phosphorescent since they have microscopic structures in their stems that reflect light if the angle is right.

Are fungi good subjects for close-up and macro photos?

Though fungi are non-flowering plants, they are highly photogenic because of their astonishing diversity of form and subtle palette of colors. Some species grow in the open on dunes or in short grass, but the best places to search for fungi are woodlands. Most species send up their fruiting bodies (the part we recognize as the mushroom) in the fall, and different woodland trees (oak, beech, birch, and pine) support their own distinct species of fungi.

The fruiting bodies decay quickly, so don't wait until tomorrow if you can take fungi pictures today. Many small fungi and tiny slime molds are easily overlooked, yet they make spectacular subjects for the macro lens. They can be found in cracks on rotting wood, on decaying fruit, and even on moldy bread and yogurt.

At the other end of the scale, dead trees will often host large bracket fungi growing so high up that they can be photographed only with a telephoto lens. Since you will almost certainly be photographing them from below, your picture will inevitably include the sky. Therefore some form of fill flash will be needed to balance the exposure against the light background. The exaggerated perspective of a wide-angle lens used at close quarters works particularly well with fungi, especially taken from a low point of view.

Photographs of fungi look best when recorded in natural light. Since light levels are usually quite low in the woods, long exposures requiring some type of camera support are necessary. A small tripod, or one where the legs splay widely, can get you down to ground level. Alternatively a beanbag works well. It also helps to have a right-angle viewfinder or articulating LCD screen. You can use artificial lighting, but fungi can be highly reflective and pictures taken with flash often exhibit specular reflection on the fungi's surfaces. Unlike flowering plants that you may want to photograph, fungi, with their stout stalks, in their naturally sheltered habitat means that the typical challenge of subject movement due to the breeze is usually eliminated.

The colors of fungi are often subtle pastel shades that produce exquisite pictures. If it is difficult to get natural-light photos, make sure to diffuse your flash, balancing its light in the foreground with existing background illumination. Portable reflectors are useful in these low-light situations, allowing ambient light to be thrown into shady areas.

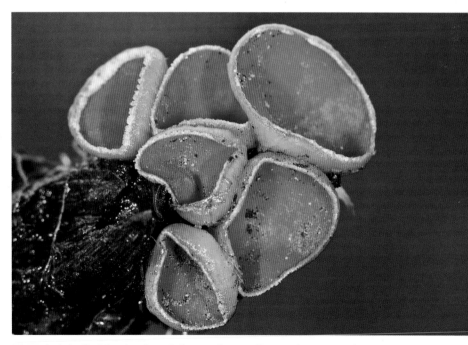

These bright fruiting bodies of the scarlet cup fungus (Sarcoscypha coccinea) appear in the depths of winter on bits of wood debris around my vegetable patch at a time when there is little other color in the landscape.

How hard is it to photograph insect wings?

From shots of whole wings to those that reveal minute details from using stacked lenses (see page 88) or even reversed lenses on a bellows (see page 76), insect and butterfly wings offer outstanding close-up and macro opportunities. Getting a picture of a butterfly and its wings in nature can be a satisfying experience because it takes superior stalking and photographic skills. Test yourself and remain patient as you follow one of these floating creatures to a landing spot. One fruitful strategy is to approach butterflies at the beginning of the day before they warm up, or at the end when they are sunning. They tend to be less likely to fly off at those times.

Another thought is to find wings that have become detached. But please, do not euthanize butterflies and moths just to take pictures. That is just not right! Instead, you may find it useful to go to a butterfly house in a nature preserve or farm (if one is nearby). If you don't mind appearing a bit odd, ask if you can have any wings they might have swept up.

Wings from insects such as dragonflies, lacewings, and flies usually show a network of veins, and those patterns often make

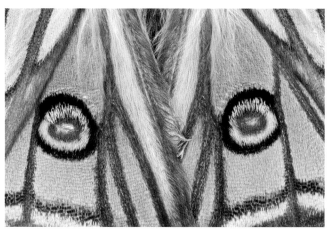

Many butterflies and moths have eyespots on their wings that they flash defensively to scare potential predators— at least that is the theory. The spots on the wings of this rare Spanish silk moth become part of a distinct "face" when enlarged to overfill the frame.

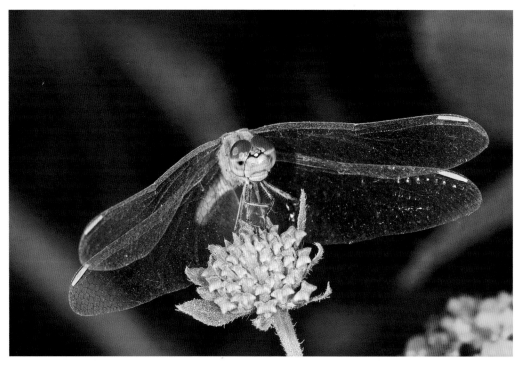

The wings of dragonflies and damselflies have a strong vein structure that support their aerial acrobatics. Being creatures ever on the alert, they are not easy to photograph. Watch the insect and note that it often returns to a certain perch—then, with patience, move in slowly.

intriguing subjects for macro shots. Interestingly, these types of wings can be retrieved from spider webs; they are the inedible bits that are left by the web builders. Regarding butterflies, spiders go for the bodies and leave the wings to fall to the ground.

The eyespots and patterns on the wings of butterflies and moths actually originate from tiny fan-shaped scales that are fascinating macro subjects in themselves. As long ago as the Victorian era (circa 1837–1900), naturalists painstakingly assembled these minute scales into pictures. I once saw one illustrating the nursery rhyme *Mary, Mary, Quite Contrary*. The patience involved must have been incredible.

These scales can be photographed on living insects using a macro lens. One method to ensure such pictures is to obtain the proper species of caterpillar and care for them until the butterfly or moth emerges. Don't disturb adult insects while their wings are drying, because they are extremely delicate and vulnerable. For perfect results, photograph the newly-emerged insect before it takes to wing.

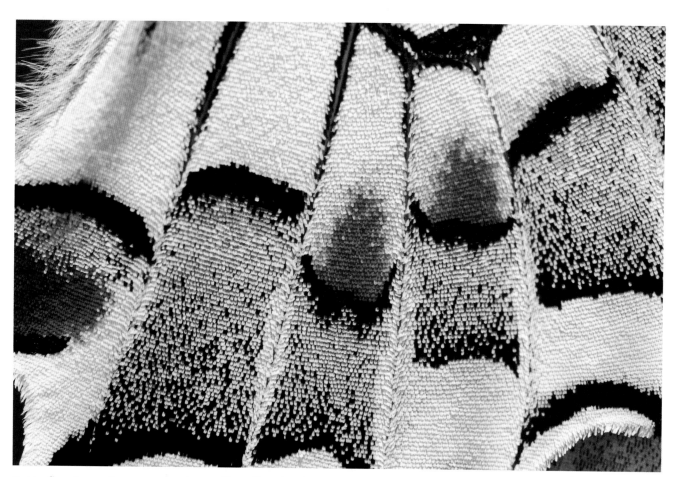

Butterfly wing patterns are made up of small scales that can test the resolving power of your macro lens. A tapestry-like pattern emerges at magnification levels of 1x – 2x, while you can clearly focus on small groups and even individual scales at higher magnification.

What makes insect faces so interesting?

Q

A Indeed, it can be truly amazing to look at the close-up features of an insect or spider, as though you are inside of their world with a bug's-eye perspective. More than a few insects have body markings that resemble eyes or visage-like patterns that are interesting and really grab our attention. In fact, a great many macro images of the insect world reveal an uncanny human character about these creatures, producing a high degree of visual impact.

We see a face as a point of contact in our photos, and it is essential that the eyes be in sharp focus, especially in shots with a shallow depth of field. Once the eyes (or anything eye-like such as wing spots) are sharply rendered, then blurred portions of the photo will be easily tolerated and, in many cases, will enhance the image by emphasizing the sharpness of the eyes.

Your natural attraction to faces and face-like markings may lead you to start collecting a rogues' gallery of insect mug shots. You might go out to shoot specific plants or animals and then, alert to the opportunities, record whatever else is around. Your collections of images will grow, and the attention you can generate with insect close-ups may soon make them a staple of any show or display you might make of your work.

To capture these types of detailed shots, you will need a close-focusing lens that projects at least a life-size image (1:1) onto your sensor. A macro lens with a focal length of 100mm or longer will preserve a

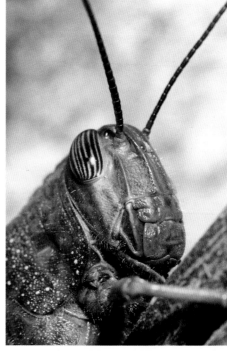

In some ways, taking a portrait of an Egyptian grass-hopper is not much different than taking a portrait of your best friend—both have faces full of character.

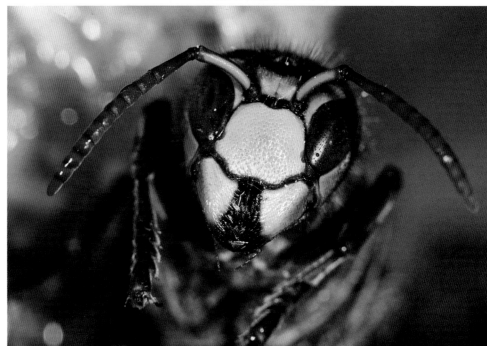

Up close, this hornet (Vespa crabro) looks deceptively benign, but its sting is very painful. To avoid stirring this hornet's wrath, I placed my camera at a respectful distance and used a 150mm macro lens with a teleconverter.

Ironically, this type of horsefly with an unpleasant habit of biting has beautifully colored eyes with reflections that change according to the direction of the light. I used a reversed 24mm lens stacked onto a 105mm macro lens, plus a lot of patience and several failed shots, to get this close.

reasonable shooting distance so that you don't scare away a sensitive subject by getting too close with your camera and lens. You can produce a magnification beyond 1:1 with supplementary lenses, such as 1.4x or 2x teleconverters, or extension tubes.

It can be inconvenient to use a tripod when trying to get close to insects, especially if the bugs are likely to move, so you often have to resort to other supports to hold a camera steady. Or, especially if your sensor manages noise well, raise the ISO setting to 800 (with or without flash) to eliminate blur from camera shake or subject movement.

I suggest you record using RAW or the largest file size your camera allows so you have enough image data to allow for a bit of judicious cropping. If you photograph insects while they are feeding, or when they are less active at the extreme ends of the day, you will often get several opportunities to capture an image. Some insects are more mobile or jumpy than others and therefore become quite challenging to photograph as they quickly move to the opposite side of a plant stem. Gently waving your hand on that side can drive them back into view of your camera, though there is no guarantee that they will follow your command.

How can I photograph raindrops and dew?

Whether it is falling from cliffs, bubbling over stones, floating boats or birds, frozen in winter streams, or surrounding a plethora of life forms below its surface, water has definite photographic appeal. You can creatively capture its energy as a splashing moment isolated in time by setting fast shutter speeds or using flash, or as a moodily blurred flow by recording with longer shutter speeds.

Water droplets lie at the other end of the rushing water scale. They can impart a definite freshness to photographic subjects, but it is easy to overdo the effect. Before taking an atomizing spray bottle and indiscriminately covering a subject blossom or leaf, look first at how nature does the job with early-morning dew or raindrops. You'll see that the beauty in a dew-filled morning often derives from nature's restraint.

In addition, water droplets delineating a spider's web provide a classic natural subject that we all try to photograph at some time or other. The result is even better if the drops have frozen. If you position yourself correctly, you can capture the scene so that backlighting from the low-angled morning sun makes

Some leaves such as cabbages and nasturtiums have a waxy surface on which drops sit without spreading. Here the droplets act as tiny magnifying glasses to the leaf veins below them.

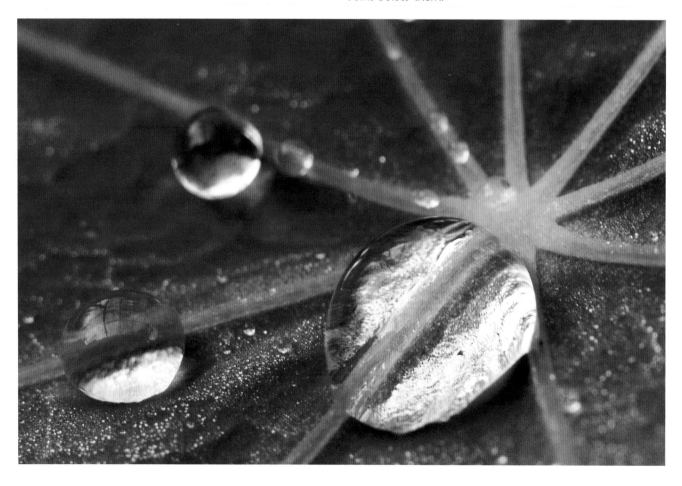

the droplets sparkle like jewels. You may even be able to capture a prismatic rainbow effect when shooting from just the correct angle.

Refraction and Reflection

When we take the time to examine raindrops closely, we can see not only how they reflect light, but also the tiny images of flowers or leaves that may be behind them. In order to photograph the reflections in water drops, go out after a rain (or during, if your camera and lens are waterproof), or catch the morning dew on the leaves of plants such as nasturtiums and cabbages—the water droplets stay compact and rounded rather than spreading out on such waxy surfaces.

A water droplet acts as a near-spherical lens with a very short focal length, so it can produce an image that is either magnified and right-side up (droplet is on the object), or condensed and inverted (droplet is in front of the object). I'll look at this a bit more closely on the following pages. As an interesting fact, the revolutionary microscopes made by Antonie van Leeuwenhoek utilized tiny oil and water droplets formed in a hole in a brass plate to examine subjects.

How Can I Light Water Droplets?

Any form of artificial lighting is tricky at first because you have to light the background while avoiding reflections on the drop's surface that can be distracting. It is always possible to fit a polarizing filter onto the front of your camera's lens and rotate it to eliminate major reflections from tungsten lamps, LEDs, or sunlight.

When you photograph a water droplet using flash, it can produce tiny images of the flash tube that you do not notice until the image is on screen. Seeing the twin bars of a macro flash will appear unnatural. The solution is to use a single flash, preferably diffused, or some skillful processing in your imaging program after the shot. In general, light the subject rather than the drop: that will make the drop's edges look darker and more dramatic.

Morning dew in the fall will often settle on a spider web creating a jeweled effect. I was able to move into different positions around this web, allowing me to record light on the drops while shooting against a shady background.

Diffused daylight, either in the field (cloud cover, fog, foliage, etc.) or in a studio, provides better lighting quality. (An indoor setup also provides protection against air currents.) Hanging drops act as vibration detectors by quivering with the slightest breeze or movement. For outside work, breezeless days are best. You will find striking images by looking for early morning dew as it condenses on inactive insects, or searching for slowly melting icicles with droplets ready to drip from the tip.

How do I photograph images within water droplets?

If you examine raindrops, dewdrops, and the like, you will find that they can act as lenses with quite interesting effects. There are two distinct types of images produced by droplets of water. The first occurs when drops on waxy leaves, such as nasturtium, form compact globules that hold together and act like magnifying glasses, enlarging the leaf veins behind them (see page 102).

The second type of image is inverted, evident when you look into droplets hanging on twigs where they act like fisheye lenses. If a drop is close enough to a flower, for example, you will see a tiny image of the flower that your eyes interpret to be inside the drop. In reality, the focused image is just in front of the drop. As a consequence, you must focus your camera lens at that point to capture the upside-down flower in sharp focus.

The farther away the flower is from the drop, the tinier its image and the more the background behind the drop will be included in focus. Conversely, to obtain a larger image of the flower, the drop and the flower must be close together, causing the smaller background area to appear as a colored blur.

Flower setups in a studio need to be mounted upside-down if you want them to appear right-side up within a droplet. Because these droplets are small, you must boost magnification with a converter, or by stacking lenses (see page 88), if you want the inverted image to dominate your composition.

Droplets formed in nature may not be in precisely the right place for the picture you want to shoot, and the slightest disturbance will dislodge them. Thus, it makes sense to take control of a scene by adding a little water to form drops and moving obstructions out of the way.

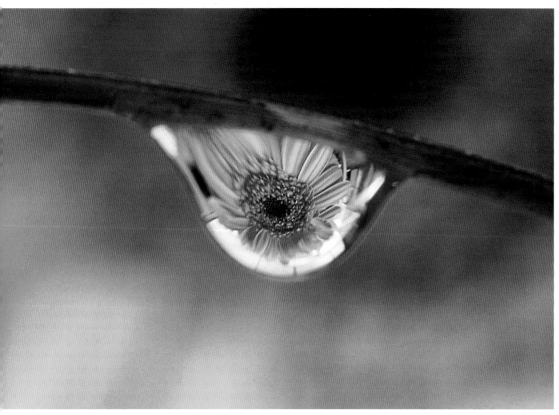

A drop of water serves as a lens to focus the flower at a point slightly in front of the drop. That means the water droplet and the flower image might be hard to get in focus at the same time unless you produce more depth of field by stopping the lens down. The actual flower behind the drop is thrown completely out of focus and provides a colored backdrop.

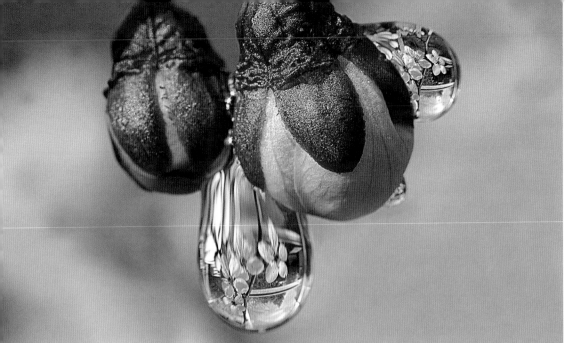

Crocodile clips can be used to hold a drop-covered twig steady while a subject is positioned behind it.

You can spray a twig and wait for tiny drops to coalesce, but it is easier to hold a dropper against the twig and squeeze gently, though control is a bit tricky and persistence is essential to get the knack. It helps to first dampen the twig so its surface soaks up some water, which allows the droplets to hold on to the twig's surface.

When attempting to get both drop and the "flower within" sharp, set the lens on Manual focus just beyond the flower image—this produces depth behind and in front of the flower. Check your camera's depth-of-field preview to ensure that the drop in front of the flower is sharp. Stop down and shift focus, or move the camera on a focus slide, to get a result you like.

You will soon get a feel for how large you can let a drop grow before it falls. Time your shots accordingly.

In movies, plants are often sprayed with a one-to-one mixture of glycerin and water. The mixture does not evaporate as easily as water alone and is thus better under the bright, hot lights filmmakers employ. Compared with pure water, the mixture's slightly higher viscosity and increased surface tension is said to create larger and more stable drops.

A few cherry blossoms on a twig are held by a stand fitted with a crocodile clip. I then created droplets separately on a small twig placed in front of the cherry blossoms by carefully using an eyedropper. It takes patience to get the timing right before the drop falls. Here, a camera with bellows was used magnify the image.

How can I capture animal action?

Fascinating action images can be obtained with a little patience by waiting with your lens focused on a flower to record soon-to-be visiting insects. If your reactions are quick enough, you might even get them as they land or take off, which is always more interesting than seeing a photo of an insect just sitting on a leaf or blossom.

When it comes to close-up and macro photography, it is no easy task to capture the precise, defining moment of an action sequence. The right instant will be easier to catch if your camera has HD video capability, since this feature in many DSLRs records high-quality individual frames. Another strategy is to use continuous shooting for taking a rapid set of pictures. This is usually more successful than recording an individual frame because it increases the probability that at least one of the rapid series of images is taken at the critical moment. You can also build tension through a sequence of images that leads to the climax of the main action.

Capturing the pinnacle of action is much more than a matter of luck and camera technology. The ability to record consistently good action shots of insects requires photographers to rely on a special understanding of their subject—call it intuition, or call it experience. Spiders, for example, may react to your presence by hiding behind

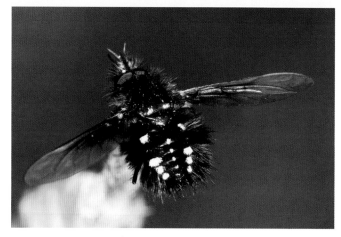

I captured this insect in flight by staking out a perch to which it kept returning and prefocusing on that spot. I used the maximum shutter sync speed of 1/250 second with flash.

a leaf; but if you avoid sudden movements, you'll learn that they will soon reappear. I have even used a vibrating tuning fork near a web to bring a spider, intent on finding the insect making the noise, out of hiding. Time spent acquiring such knowledge goes a long way toward helping to capture shots that few other close-up photographers can manage.

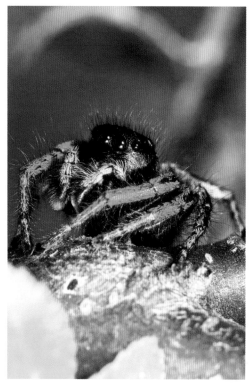

Many small creatures flee at the first sign of perceived danger, but jumping spiders have an almost cheeky response—first hiding and then coming out as if intrigued. Don't be fooled, you do not have a lot of time. Take your shots quickly before they leap away.

What about photographing in a butterfly house?

Tropical butterfly houses enable people to examine butterflies up close and see species that they might not normally witness. The best establishments serve to educate the public about types of butterflies that are at risk, supporting conservation programs in the country of origin of the species they display.

Many butterfly houses are sympathetic to photographers and, when they are not crowded, afford you the luxury of photographing in a relaxed manner. If you want to use a tripod, however, you should always phone ahead to see if

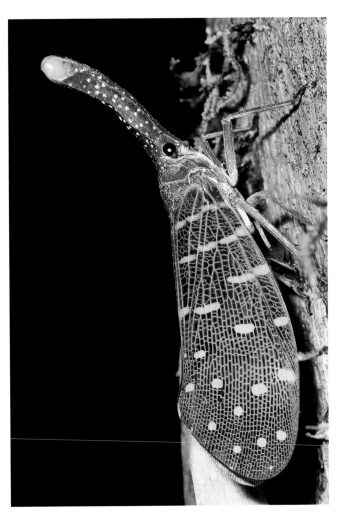

it is allowed. Once inside, even on dull days, you will find colorful butterflies of many varieties that sit still for long periods of time, often with their wings spread, allowing you to take photographs in natural light. But for those spectacular specimens that always seem to sit just out of reach, a telephoto or tele-macro lens is useful to have. Leaf cover in butterfly houses can create deep shade, so it is also useful to have flash with a diffuser—or a macro flash—on hand. Provided the insect is not too far away, a camera's built-in flash can work surprisingly well.

The patterns formed from the tiny scales that make up butterfly wings are fascinating macro subjects (see page 98). This may sound odd, but the best source for these minute scales come from dead butterflies, since they won't move suddenly when you try to record such shots. Think about asking the manager at a butterfly house if you can collect the wings of dead butterflies found there—a strange request, perhaps, but it may be worth the effort.

One problem in warm, enclosed areas like this is the possibility that condensation will form on the front of your lens and on eyepieces. This happens when the camera is colder than the surroundings, though the problem disappears as the camera warms up. To anticipate this when photographing in butterfly houses or tropical orchid houses in wintertime, keep your gear warm (in your car with the heater on) before entering the hot, humid environment.

One of my unfulfilled ambitions, twice thwarted (but not forgotten), has been to go to Borneo. Imagine my envy when my son Rhodri emailed me this shot he took of a lantern bug (Pyrops candelarius) while in Borneo. Tropical houses offer us the chance to see small creatures from other parts of the world that we would not otherwise witness—an experience that makes us richer realizing we can so easily lose those treasures. © Rhodri Davies.

How can I tell a story with my pictures?

One vital aspect of nature photography, and therefore close-up and macro photography, is the ability to tell a story through your pictures—and there are a million and one stories out there. Animal action is often unpredictable, but there is one magical transformation that you can count on and capture with a little bit of patience: the emergence of a butterfly from its chrysalis.

Near my studio door grow some tall fennel plants I share with the colorful, striped caterpillars of the Swallowtail butterfly (*Papilio machaon*). They feed until they can eat no more and, after a period of restless walkabout, they settle to spin a gossamer girdle, then shed a final skin to become a chrysalis.

You cannot predict the precise moment when emergence will occur, but there are clear signs to prepare you. After about three weeks, you will see the wing pattern begin to appear through the sides of the chrysalis—the sure sign emergence is no more than a day away.

Over the next several hours, these patterns become clearer as the insect within secretes a fluid to thin the protective walls of its case and facilitate emergence. Shortly before the butterfly's appearance, you will see slight wriggling/flexing

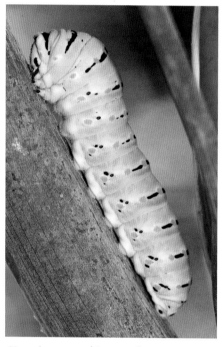

Knowing some history about your natural subjects can be helpful for the serious close-up photographer. When ready for its metamorphosis, the colorful caterpillar of the swallowtail butterfly (Papilio machaon) attaches itself to a stem by a strong silken thread and discards its skin to produce the chrysalis.

movements. Now you know action is imminent, and you need to have everything set up to go.

At first, the top of the chrysalis splits and the head emerges, then the butterfly will struggle to free itself and latch onto a twig or its discarded pupal casing. The butterfly is fragile and vulnerable to predators at this stage as it begins the rhythmic movements that pump fluids into the veins in its tiny, vestigial wings. They expand over a matter of minutes until they seem complete, yet the insect stays still to dry for some time before taking a maiden flight.

Eventually, while hanging there, it will open its wings to dry the inner surfaces. Now you see the perfect insect—no faded colors or ripped wings. It is the only open-winged view you get with those species that rest with wings closed.

If you are careful not to disturb the butterfly at this point, you have an opportunity to point a macro lens at the wings and record the tiny scales that make up the exquisite pattern. Never touch those wings, for they are delicate and the butterfly can become crippled. In fact, insects raised in captivity suffer from a fair degree of deformation. For photos of the best wing patterns and formations, it is better to look in your garden for caterpillars, rear them outdoors and then, after emergence, release them where they belong. By all means photograph at butterfly farms, but never release non-native species back into the wild.

Nothing happens with the chrysalis until a day or so before emergence when the casing becomes transparent and the unexpanded wings can be seen. Emergence could be in a day or in several hours—it might take several attempts to understand the timing involved. Patience and study is essential. The insect produces fluids that soften the casing and the split is almost imperceptible—just a slight movement before the butterfly quickly emerges. If its expanding wings get caught in the chrysalis, the butterfly becomes trapped and will die. This can happen if the chrysalis is handled.

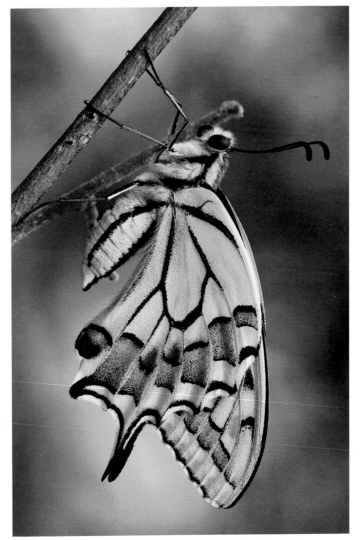

The insect sits and fills out its wings over a period of hours by pumping fluid into them. With wings expanded and dried, the imago (final butterfly stage) is in a perfect state to photograph before it flies off to live its life.

How can I capture insects in flight?

You can get impressive shots of insects in flight with nearly any DSLR thanks to the present-day camera's ability to synchronize flash at speeds higher than 1/250 second. In fact, flash sync speeds of 1/320 and higher (up to 1/8000 second) are available when using external flash units with cameras that have Auto FP (focal plane) flash capability. There is a reduction in power output, but light intensity is still sufficient at f/16 with a modest-sized flash. You can experiment with the ISO setting to get a mix of flash and daylight for a natural look. Many more possibilities are opened up when using devices with photoelectric triggers, such as Phototrap (see page 112).

The No Frills Approach

Hummingbird hawk moths (*Macroglossum stellatarum*) work tirelessly among the nectar-rich lavender bushes and, later in the year, Buddleja. Multitudes of different insects are attracted to bushes like these in the summer, and with patience you can set up near them to seize the opportunities.

I noticed that the background beneath the bush was in shade but near enough to the subject so the flash could illuminate it. Hawk moths are daytime fliers, so you need to be aware of ambient light when shooting in full or partial sun. Exposure of the background should be kept to a stop or so below that of the main subject.

To freeze action and get good depth of field on your flying subject, set the camera's extended sync speed capability and make adjustments in Manual exposure mode, e.g. 1/320 at f/16. Then, adjust the ISO setting while checking the exposure indicator in the viewfinder so that the background is a stop below optimal—it usually works at about ISO 400.

One method is to set the camera plus flash on a tripod and watch for insects to come towards a flower. Move the camera setup to alter the field of view until you find one you like. Since many lenses in autofocus mode will hunt to focus on a moving subject, switch to Manual focus and fractionally adjust focus with one hand on the lens. You need quick reactions or, better still, good anticipation.

Flight shots can also be made with a handheld camera plus macro flash, which is a good technique to use when wandering in a flower-rich field. Look for a variety of flowers to use as different backgrounds to lend diversity to your pictures. The key is to wait, aiming at a suitable flower and watching what comes along. The technique is easy and effective with high-speed sync capability. With practice, you can achieve a high rate of success capturing insects in flight.

Do I Need a Special Flash Unit to Freeze Action?

A normal flash pulse lasts about 1/1000 second, which is fast but not sufficient to freeze wing movements in moths and birds. High-speed flash units are usually expensive. Fortunately, there is a viable alternative that involves automatic flash units when used on their Manual setting. By using fractional output power, the flash duration is shortened.

I caught this iridescent rose chafer beetle (Cetonia aurata) right at take-off while experimenting with a wide-angle lens.

The table below lists estimated pulse durations at reduced power for typical accessory flash units used in this manner.

1/880 second at full output
1/1100 second at 1/2 output
1/2550 second at 1/4 output
1/5000 second at 1/8 output
1/10000 second at 1/16 output
1/20000 second at 1/32 output
1/35700 second at 1/64 output
1/38500 second at 1/128 output

How does an IR trigger work?

The delicate dance of tobacco flowers (*Nicotiana*) heralds the arrival of hawk moths (*Agrius convolvuli*) at dusk, when the rapid motion of the insects' wings generates a breeze that seems to bring the flowers to life. To capture these insects in flight, some photographers use an infrared (IR) trigger accessory, one example of which is know as the Phototrap. As an insect (or bird) crosses an IR beam, it breaks the invisible circuit between detector and emitter (like a burglar alarm) and triggers the device to fire the camera and its flash. This technique was used to record the large moths in flight at twilight (below and at top right) when the flash exposed the photo with no need to worry about ambient light.

The Phototrap—trigger, controls, and battery—is permanently fixed in a black, impact-resistant plastic case. Long leads provide connection to the sealed transmitter and detector units, with the detector and transmitter separated by as much as 6 – 8 meters,

It's helpful to know the habits and favored habitat of any flying insect to capture them in flight. For example, sphinx moths use their 5-inch (12 cm) proboscis to suck nectar from the corolla of the tobacco flower. It was not difficult to figure out camera placement in such a field, then set up the trigger and wait for the action.

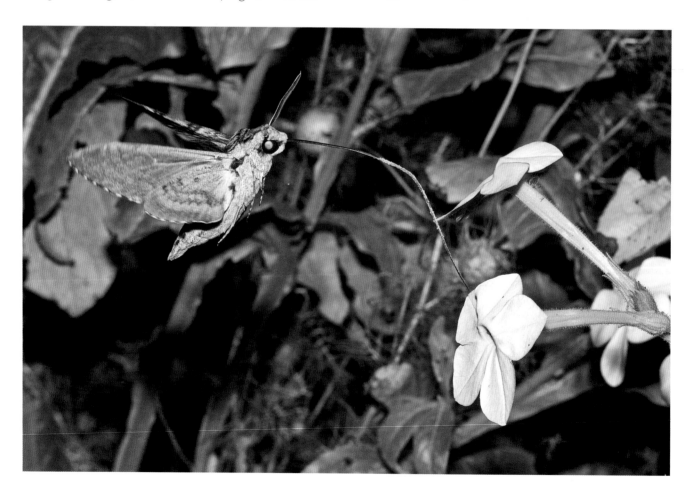

(20 – 25 feet). A lead also connects to the camera with a plug to fit Nikon or Canon (you specify) and the on/off switch. To trigger the shot, the switch must be turned on, to view images on the camera's LCD, the switch must be in the off position. You can vary the intensity of the IR beam, the sensitivity of the detector, and the speed of recycling before the unit resets from the controller. Since the trigger pulse is insufficient to operate autofocus, you should focus manually on a spot where you anticipate the action is going to occur. It is important not to move in too tightly or you may end up getting only part of your subject in the frame.

The Phototrap unit has different modes. In Direct mode, the camera and flash fire when the IR beam is broken. There is a delay of approximately 10 milliseconds between the time the beam is broken and when the camera fires. Alternatively, the Reflect mode (the one I use most) is an ingenious function where the detector and transmitter are fixed together with velcro. The combination is placed below a nest box, a hole in a tree or wall, or a flower, for example. The IR beam will bounce back from the body of the subject to trigger the camera and flash in a few milliseconds.

Shutter Lag

There is always a very short but nonetheless significant period between the time when the shutter release is pressed and when the sensor records the image, due to the operation of the camera's internal electronics as the sensor is charged. Fast flying creatures can move during this interval and be out of the picture if you don't have a wide field of view.

With a Nikon D300, for example, shutter lag differs according to whether you use 12-bit or 14-bit capture mode—it is faster with 12-bit but still about 50 milliseconds (0.05 second). This limits the setup even

Because of the long proboscis, this aerial acrobat can sit far from a flower and trigger your flash, as well as move up, down, or hang its body in a vertical position. After focusing too tightly and only getting shots of half an insect in the frame, I pulled back.

Getting pinpoint sharpness is somewhat trickier than determining camera placement when using a trigger. I moved my finger along a projected flight path for the moth to see where the flash would trigger and to figure where my lens was focused. However the moths can break the beam and move slightly in the time it takes f or the camera to fire, so my success rate was about 25 – 30%, which is actually quite good.

when the Phototrap is capable of triggering in 0.01 second. You can try to anticipate how far the subject will move and adjust the camera position accordingly, or use a fast external shutter.

How can I best photograph the beauty of orchids?

Many of the photographic challenges we face in terms of lighting, composition, depth of field, and distortion come from the fact that we are rendering two-dimensional images of three-dimensional objects (unless, of course, we are taking image pairs for stereoscopic viewing).

For example, orchids are far from the easiest of flowers to photograph because of their variety and complexity of form and structure. Study several orchid blooms to learn about positions from which to photograph them and ways of lighting them, as their elaborate three-dimensionality can cause problems. The lessons learned can be used with other intricate flowers, such as passion flowers (Passifloras) and lilies.

Many orchids that are primarily flat can be photographed fully head-on to exploit their bilateral symmetry. Others will better reveal their captivating appearance photographed from a different angle. A useful starting point is to approach the front of the flower from the right or left at approximately 45°, then photograph from above or below by roughly the same angle. But don't stop there; continue to move your camera to explore the possibilities of each flower. After a while you will get to know what points of view appeal to you and to viewers of your photography, so you will position yourself instinctively.

For orchids, both large and small, groups of two or more flowers can be used to create an appealing composition, particularly where the flowers point in different directions and you can reveal more of their structure. When shooting larger orchid flowers, it can be helpful to move in as close as possible, where it is easier to emphasize elements of pattern, design, or structure by filling the frame.

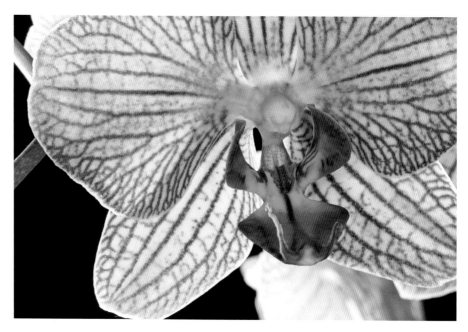

Orchid flowers are complex and intriguing—they have an air of the exotic. A pot-grown hybrid such as this Phalae-nopsis offers a chance to try techniques like using some back-lighting in addition to frontal lighting to bring out the veins.

Some orchids have flowers that are merely a few millimeters in diameter. Careful control over depth of field is essential when working with small subjects in the macro realm, where magnifications are life-size and larger on the camera's sensor. Make your aperture larger to minimize depth of field and produce a generally "artsy" look, or maximize depth of field by using small apertures. Image stacking with orchids also produces astonishing results.

When practicing close-up photography, depth of field is distributed nearly equally in front of and behind the point of sharpest focus. One strategy I sometimes use with orchids is to decide on a point of interest and locate it at the farthest reach of the depth of field, with as much in focus in front of that as possible. In this case, you will probably need to experiment with a depth-of-field preview button, taking a few shots and examining them closely by zooming in on the LCD screen to see if you are, indeed, fixed on the optimal focal point.

* Orchids are great subjects you can use to hone your photographic skills to become a better plant photographer—get it right with orchids and many other flowers will be easier.

* Given the choice, use natural light for close-ups of small orchids, though you can also use a subtle mix of flash and background light. With tropical orchids in nurseries or botanical gardens, there is often a clutter of foliage behind them; it helps to isolate the flower with a long-focus macro lens.

* Experiment with black backgrounds and backlight when photographing plants growing in pots. In this way, you can highlight the tiny hairs that grow on the stems and also emphasize the inherent translucent nature of the flowers.

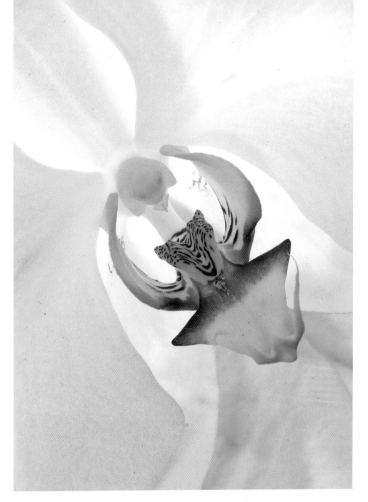

Shots of part of an orchid can make worthwhile compositions. Here the subject was viewed diagonally, which tends to produce a dynamic view of an otherwise static subject. Natural backlight came from a window behind the orchid.

Wild orchids, such as the marsh helleborine, often reveal their beauty when recorded using a macro lens, rivalling the exotic look of their tropical cousins, which is why many people are drawn to them.

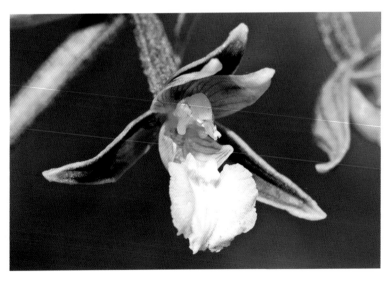

How do I shoot pictures of wildlife in streams, ponds, and rock pools?

You can take photos of subjects such as rock formations, colorful plants, amphibians on logs, feeding fish, etc. that are under the surface of a stream, pool, or pond by positioning the camera carefully to avoid reflections from the water. Stand still and watch for the wind because anything that creates ripples on the surface will obscure the image. The simplest method is to position the camera on a tripod so that it looks directly down into the water with its back parallel to the surface. By wearing dark clothes and standing over the camera (or holding a large black umbrella), you can eliminate upward reflection from the water. However, use care if you shift position, because reflections can creep into the corner of the frame; and, if you are standing in the water, sand and other particles can become disturbed and float into the picture.

Cloudy days often provide the most challenging lighting conditions because the light has no pronounced direction, so that surface reflection becomes more confusing and difficult to control. An accessory flash with diffuser can be held away from the camera so that none of its light is reflected directly from the surface back into the lens (below left). Experiment by looking at your histogram as you shoot; you might need to increase exposure to compensate for light absorption by the water.

The bird's-eye view can be limiting when you stand looking down into water with your camera, but it is not hard to make a periscope that lets you see the water's inhabitants as if you are down there with them (below right). You will need a single, blemish-free mirror set at 45°. The best mirrors to use are front-silvered type, obtainable from optical suppliers, because the chances of ghost images are decreased since the light rays don't have to travel through a layer of glass twice—which they do on their way to and from the reflective surface of a normal back-silvered mirror.

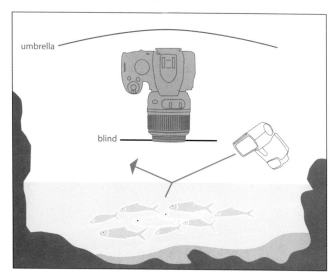

A flash held at 45° or more to the vertical avoids reflected light entering the camera lens. A blind around the lens will prevent the camera's reflection from appearing on the water's surface.

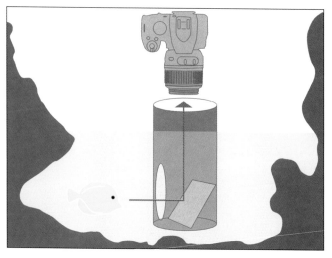

The mirror is glued to a wooden block cut at 45° and the side hole is covered with glass from a picture frame.

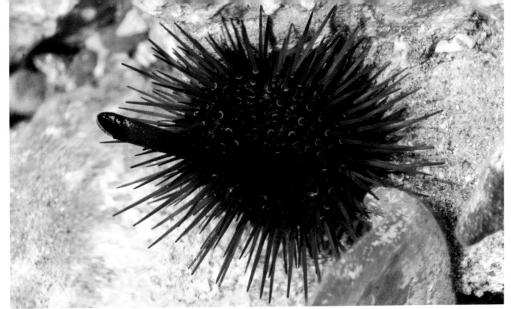

I photographed this small sea urchin (Paracentrotus lividus) in a rock pool by tilting the camera on a tripod, estimating "Brewster's angle." A circular polarizer was rotated until the view into the water became clear, while a black umbrella was held over the pool. A diffused flash placed to the side provided the illumination.

As an alternative to holding the camera directly above the water's surface, you can hold it at an oblique angle from the side and fit your lens with a circular polarizer (linear polarizers don't function with AF systems). Surface reflections usually disappear when you hold the camera at 53° to the vertical (called Brewster's angle, the effects of which were discovered by 19th Century Scottish physicist, Sir David Brewster). At this angle, the reflected light has its greatest degree of polarization and can thus be cut out most effectively.

In addition to a periscope, a simple, homemade viewing tube allows you to record wildlife below the water's surface. This can be made from a length of plastic drainpipe sprayed matte-black inside with a glass plate cemented to one end with silicone cement (see below). When choosing glass to use as a window in the viewing tube, the 2 – 3 mm glass used in small picture frames works well, though for larger areas and thicknesses it is possible to find optically clear glass from specialist suppliers that is polished on both sides to be perfectly flat and distortion free.

Rock pools near the sea, particularly at low tides, hold a wealth of fascinating creatures—shrimps, small fish, hermit crabs, and sea anemones all make fascinating photographic subjects. But salt water and camera electronics do not mix. A plastic cover for the camera would be a good investment if you want to do this kind of photography on a regular basis. In fact, a plastic cover is a pretty good idea for any beach photography, because breezes are laden with salt-water droplets and fine sand particles that are highly abrasive. Blow off any obvious sand after a trip to the beach, dust with a soft brush, and then use a moistened cloth to wipe any salt off of the camera body.

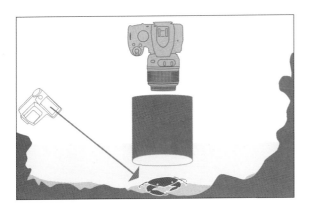

A viewing tube takes you down to the subject while the camera is safely above water.

Studio and Post-production Work

There are plenty of ideas for practical indoor work when you are not in the field, especially when the weather outside is unfavorable for taking pictures. And some subjects, especially very small ones, are more easily photographed at home where you can set up your own small studio.

Additionally, as a digital photographer, there are things you must do indoors with your computer, no matter how much of an outdoor person you are. Filing, sorting, adjusting, and changing your photographs can be a headache, but now there are programs such as Adobe Lightroom that provide a solution, no matter how large your collection. Digital workflow and post-producton are regarded as essential by those who think of themselves as photographers first, even though they would prefer to be outside getting images.

This section will help you make the most of your time spent indoors—from building your own macro studio to streamlining digital workflow—and show how being inside doesn't have to hold back your photography.

How can I set up a small home studio?

The beauty of close-up photography is that it takes very little space to provide for a fully functioning studio setup. A sturdy table almost always serves the purpose. All you need is a setup in which your subjects are sheltered from air movement. Plexiglass or translucent acrylic panels, arranged with two sides and a back set on the table or workbench, make effective windscreens when the windows are open or the air conditioner is on. The rest is up to you; you control the shooting, experiment with the lighting, and get the great results.

If you have a garden, you can bring small, living creatures to an indoor setup and return them quickly, without harm. If you are interested in photographing fossils, crystals, old engravings, or other inanimate subjects, you can set up a copy stand in your home that is always at the ready for such photography. You can buy a commercial copy stand built for this purpose, or you can put one together using the base and column of an old photo enlarger. This will have a mount for the enlarger head that you can unscrew to attach a camera mount. The original mechanism for moving the head up and down can do the same with your camera in order to accommodate objects of different sizes as well as a range of reproduction ratios. A permanent setup helps provide consistent results and avoids the nuisance of assembling and dismantling your workspace each time.

Lighting for a large studio can be complex and expensive. With a tabletop studio, however, you can get first-class results using quartz halogen desk lights or LED lamps that cost only a few dollars each. With these, you can create everything from shadowless tent lighting (see page 121) to dark field illumination (see page 64). Alternatively, for close-ups in the field against a white background, I work with a single panel supported

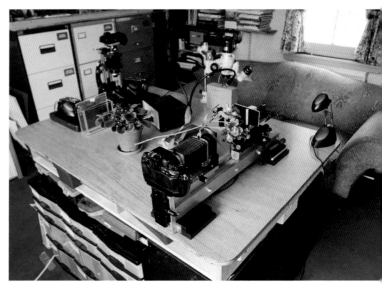

This tabletop studio (on four filing cabinets) gives me the luxury of having things set up and ready to go, which makes a big difference in my productivity and motivation to take close-up photos. It is constructed of a homemade optical bench, an old microscope stand turned into a macroscope, several lamps, and a Zeiss Tessovar lens.

behind a plant with a flash unit about a foot away, its wide-angle diffuser in place and set manually to 1/8 power.

Beware of incandescent lamps because they generate heat that may harm or kill insects and make plant specimens wilt. For these fragile subjects, flash is ideal as the main light source, though it is essential to have other lighting which makes it easier to focus and allows you to distribute the light to optimize the look you want. Low voltage LED lights are ideal for this. A few sample shots will quickly allow you to adjust the balance of the light and set the white balance. Use your camera's live view feature (if available) to quickly see the result of any repositioning of the lights.

How can I reduce reflections on shiny objects?

Unmodified flash and other lighting equipment can act as point sources and create "hotspots" due to reflection. With highly polished surfaces, such as metals or wood, it is almost impossible to cut reflections completely. Commercial dulling sprays are often used for objects in a studio, though that is usually obvious upon scrutiny of the image. These sprays are clearly not meant for beetles and other shiny living creatures.

Two simple steps can help to reduce reflection:

1. Move the light source closer to the subject

2. Broaden the light source by using diffusing screens made of tracing paper or translucent acrylic.

Square or rectangular diffusers and reflectors help control highlights more acceptably than those with more sides or irregular shapes. Generally, you can only reduce these specular reflections; to eliminate them completely might be impossible without the aid of a sophisticated image-processing program, though

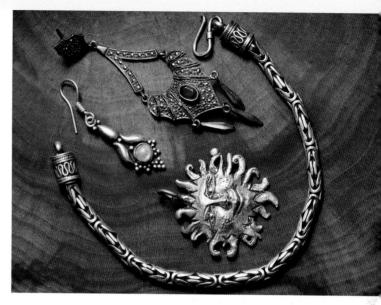

These shiny pieces of silver jewelry were placed under a cone of translucent plastic with a large diffused flash on one side and a reflector on the other. This provided enough diffusion to reduce glare, yet sufficient directional light to also provide a modicum of relief.

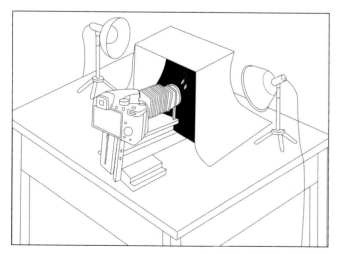

Lighting tents are excellent accessories for spreading light out to reduce both reflection and shadow, and are particularly useful when photographing anything that is shiny or polished.

retention of a few highlights may be beneficial if they indicate the glossiness of your subject. You might also consider taking the object outdoors and photographing it under a sky with light cloud cover—nature's largest diffused light source.

Still another route to consider is the use of a light tent (left), which is diffusing material that surrounds the subject and is lit from the outside. These tents are commercially available, but you can easily make one yourself from tracing paper/acetate or even a white bed sheet draped over a wire frame. Position your camera so the lens enters the tent through the open front. Place two or more lamps or flash units outside the light tent, because a single light may be too directional. Take some test photographs to check the results using the lighting setup, looking to see if any hotspots still exist. If so, try different lamp positions.

How do I light a tabletop studio?

Diffused natural light of the kind found on a day with light cloud cover is ideal for plant portraits, for example, if you can set up your tabletop studio on a bench in a greenhouse-type environment. If you are not able to use natural light, a powerful accessory flash unit with a diffuser to create a broad field of illumination can be substituted.

However, for better control over lighting and maximum versatility, a three-light setup is a great system. I have used desk lamps in the past, though like any incandescent lamp, they give out heat that can affect plants and animals. Bright white LED lamps are now widely available and a better choice. The lights should have the same color temperature (not a mix of cold and warm sources, for example), but need not be identical in output because you can experiment with them in different positions to produce effects that enhance the scene. One acts as the main light, another as the fill light, and the third provides backlight, which is ideal for displaying veins in translucent flower petals or showcasing small hairs

on a flower stem or an insect. Backlighting is often overlooked, yet it is simple to set up, and it very often brings a little magic to otherwise mundane shots.

A small studio is a great learning laboratory for understanding how to light your close-up and macro subjects. Certain types of lighting, such as axial and glancing, are important to learn about and appreciate, as are more conventional and straightforward methods.

Studio shots of plants can often look dull, but backlighting usually makes a difference, empha-sizing transparency and highlighting such characteristics as veins and hairs on these plants. This stem of wild oats photographed against a colored background was lit with three small desk lamps: two in front with one behind and to the side. The spider was noticed later.

Axial Lighting

Although shadows are important for creating relief, there are times when you need the shadow-free light found with a ring flash to produce more diffuse illumination. This is called axial lighting. Electronic

components, crystals in a geode, and interiors of watches, are all examples of subjects that can benefit from this type of lighting. If you don't own a ring flash, you can produce axial lighting in your home studio by tilting a sheet of glass at 45° to reflect direct light from the front—even from a strong flash—down onto the subject. The camera positioned above the glass picks up light reflected back from the subject.

Glancing Light

Glancing light comes from the side and is effective in enhancing the impression of sharpness. It is best used when your still life subject has protrusions, patterns, ridges, or raised details, all of which create shadows that produce relief within the image. It is an unforgiving kind of lighting in which tiny scratches and marks on the surface of objects become clearly evident.

Naturally, there is a risk of reflections arising in shiny surfaces that might result in an image of the camera, or even of you (the photographer), in your photo. These can be eliminated using a matte-black card that has a hole cut in it for the lens to poke through.

My late grandfather was presented with this watch over a century ago for his regular chapel attendance. Side lighting reveals scratches and the machining marks on the gearing. On certain valuable items, such blemishes, scratches, and machine marks serve to identify the object, particularly for insurance purposes.

The differences between axial (left) and glancing light (right) are evident when examining objects with strong surface detail. Axial light does not create shadows, providing broad illumination for a wide range of subjects; glancing light illuminates every tiny mark and speck of dust on a subject.

How do I create a perfectly white background?

Pure white backgrounds offer a fresh look at familiar creatures and plants by replacing the extraneous and distracting backgrounds often found in nature. They can be used both indoors and out with equal ease. To create such a background, set a translucent white acrylic panel behind your subject and light it from the rear with an accessory flash set on Manual to illuminate the panel uniformly. Flashes operated by the camera's TTL system then provide lighting for whatever subjects you place in front of the background.

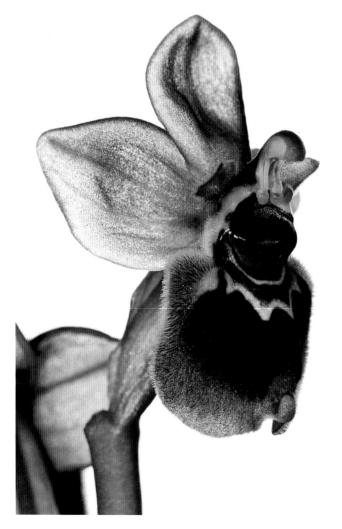

Exposure

Getting the right exposure to produce a perfectly white background can be tricky, but experimentation pays off. Start by setting the camera for Manual exposure and pointing it at the white acrylic panel without the subject present. Use the highest sync speed available (e.g. 1/250) with a small aperture (f/20 or f/22) to fire the flash (set in Manual flash mode) behind the acrylic. Review the recorded image, looking to produce a completely white LCD screen. The idea is to get the image as white as possible without blowing out—check the histogram to look for spikes far to the right (without clipping) for each of the red, green, and blue channels. The recorded background in your imaging program should read 255 in each color channel. Make adjustments as needed by moving the flash or modifying its power ratio. Take notes so you can repeat the setup in the future.

Next, set up your subject and light it with your TTL flash system, using the camera to control exposure. Make several recordings, reviewing your images to be sure you are achieving a balance between detail and translucence. A couple of flash heads will suffice: one for the background and a diffused one for the frontal lighting. It might help to set the camera to show overexposed areas during image review—the background should blink, but not the foreground.

Isolating your subjects against a white background is a great way to make pictures that are a bit out of the ordinary. These types of photos often display an intriguing mix of front and backlighting that produces a translucent quality that is unobtainable any other way.

The distance between subject and background is important. A pure white background acts as a backlight, making the subject appear to glow and producing a translucent look around its outline that enhances edge details such as fine hairs on flower stems or insect legs. The nearer the background is to the subject, the stronger the illuminating effect. With dark or opaque subjects, the background is best kept close; with lighter subjects, move it farther back.

For those doing this work on a regular basis, the flash setup should produce consistent results, providing pure white from corner to corner. Use a diffused flash for frontal illumination if you don't own a macro flash.

Which Subjects Work Well Against a White Background?

Flowers, invertebrates, amphibians, and reptiles all look great against a pure white background because the backlighting through the acrylic panel often reveals a translucency at subject edges creating a kind of glow. When photographing invertebrates, a curved sheet of clear material placed between the subject and the background can help keep the subject in the general position you need it to be in. For amphibians and reptiles, I use a small acrylic glass tank in front of the white background. Isolated in

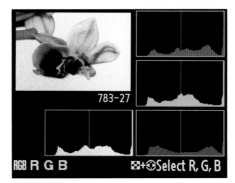

You can see the strong spikes of red, green, and blue along the right axis in each of the color channel histograms— they represent the white background. This wild orchid, illuminated by a macro flash, contributes the rest of the tonal data in the histograms.

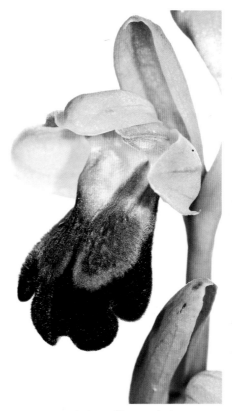

I used a simple but effective lighting system with the flash set behind a translucent panel to record this native orchid. The photo will be used as part of the Meet Your Neighbors (MYN) project, aimed at making people more aware of the world around them.

this way, the subject looks stunning against the pure white.

It is important to know what you are doing when working with amphibians, as they are in serious decline worldwide thanks to the havoc humankind has wrought with pollution. Always use purified water in your tank and clean the tank after each use. Before you put any creature into the purified water, be sure the water matches the temperature of the creature's home waters. You can do this by placing sealed bottles of the water into the habitat water long enough for the temperatures to match up. And never handle the amphibians with your bare hands; use gloves.

To avoid reflections from the tank, use front lighting with a single diffused flash from above. Adjust the exposure to be around f/22 and 1/200 second and exclude ambient light. This can be done with boards painted matte black or panels made from black card stock. Practical problems include dust or particles on the front of the tank or bubbles on the inside. Plus, acrylic plastic is easily scratched, so that can pose a problem if your tank has seen a lot of use.

How can I get good pictures of animals in glass enclosures?

Reflections represent the biggest challenge when it comes to photographing through glass. One common technique to manage this is to use black cloth or black paper on cardboard to create a blind. Cut a hole in your blind and mount it onto your camera by placing the hole around the lens. Be sure that the blind is not so large that it casts shadows or blocks the light from reaching the subject.

Another method involves making a lens hood from a plastic drain cap sprayed inside and out with matte-black paint. You could also use a small plastic tub with a hole cut in the bottom. Press the large open side against the aquarium glass with the lens through the hole in back. This somewhat limits the use of macro lenses because you are a fixed distance from your subject(s) with a restricted range of focus. Shooting this way works best with a zoom lens.

Whether you are working with a dry set or an aquarium, pay careful attention to the plants, rocks, and natural materials used in the tank. There are many excellent books that tell how to do this. If you prefer to use a background, it can be mounted a few inches behind the tank and illuminated separately from the side with a remote flash slaved to the main flash.

Though enclosures allow greater photographic control than natural habitats, it is not good for animals to be uprooted and transported. For this reason, photographers often carry a small aquarium. They remove the wild creatures from their native habitat and place them into the aquarium just long enough to get a good photo, and then carefully return them. If you decide to try this, make sure you don't have to transport very far to your tank, so that you can move your subject with minimal stress. Additionally, aquatic animals taken from their habitat can expire quickly because water deoxygenates when warm; so be fast!

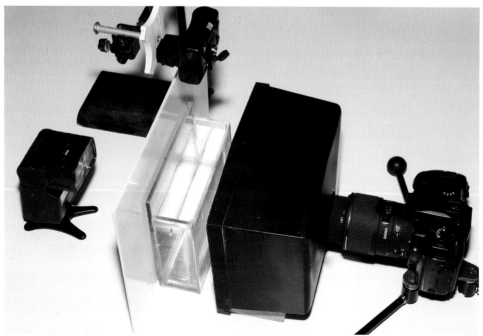

As has often been written, necessity is the mother of invention. Be sure to place a homemade lens hood against the glass side of an enclosure to eliminate reflections.

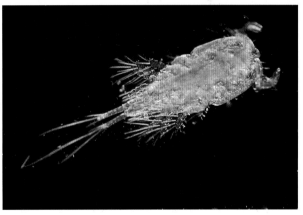

Flash

It is best to fit your camera with two small flash units mounted on a bracket to use flash effectively when photographing through glass. In any large aquarium, light falloff from the flash can mean that subjects will appear against a black background in your final images, but using a more powerful flash with a diffuser can help overcome this. You can use normal tank strip lighting for focusing, and flash for the main exposure. Avoid photofloods or any form of incandescent lighting that produces heat, because that can harm your tank-bound creatures.

This aquarium photo is intriguing because my colleague Clay Bolt isolated the swimming frog against a white background. The picture is part of the Meet Your Neighbours project to make people aware of the wildlife that shares their environment. © Clay Bolt.

The Micro Aquarium

Dark field illumination (see page 64) is dramatic if subjects are translucent since they appear backlit but on a black background. Light from the properly placed flash units will illuminate a subject swimming in a Petri dish that is set slightly above a black background, but not so far above it that the base of the dish reflects light. You can also set up with a white background to produce interesting animal photos (see page 124).

I got this little Cyclops species—less than one millimeter long—as it happened to swim past by photographing down into a Petri dish (that was placed upon a black background).

You can get striking images of tiny aquatic creatures with a homemade micro aquarium. It's no more than a Petri dish, or even a piece of thin acrylic with a "U-shaped" cutout that has been sandwiched between two small pieces of glass (e.g. microscope slides).

What is a copy stand?

A copy stand is a useful device if you ever need to photograph flat subjects. You can purchase one, or make you own. On a copy stand, the camera is held rigidly, directly above a flat baseboard where the object to be photographed sits. The camera back—and therefore the sensor—should be parallel to the board. Some form of gearing moves the camera toward or away from the subject to compose the frame, or you can use a zoom lens with a close focusing capability. Scanners are also useful for flat objects (or those with little depth, see 130), but a copy stand can handle those things that do not fit on a flatbed glass plate, such as books that will not lie flat.

The stand from an extra enlarger is ideal—you can remove the enlarger head and fit a camera quick release to it. The subject can be lit with a pair of flash units, desk lamps, or purpose-built lamps fitted with photoflood bulbs. A light box placed on the baseboard will allow you to photograph translucent objects. This work gives new life to slides and old glass negatives collected from film photography. I have even digitized parts of local Italian maps, put them on a laptop, corrected them, and drawn walking routes on them.

Anything that can be laid flat can be photographed using a copy stand, including maps, stamps, banknotes, lace, or any host of objects. In general, when making copies of photographs or paintings, it is better to remove them from their frames. If this is impossible, then clean the glass thoroughly and make sure the lighting is at an angle of about 45° to the surface in order to minimize reflections. A polarizing filter fitted to the front

It is common to photograph a book on a copy stand under a glass plate to keep it flat. But rather than rest the plate on top of the book and risk damage to the spine, it is better to raise the book on scissor jacks up to the plate.

The books of David Roberts are long out of print, and the originals are much prized. A friend of mine has a set with all of the superb Victorian illustrations that show explorations in Egypt and the Holy Land. So now I have the next best thing to an original set: digital images of these illustrations printed on fine-art paper.

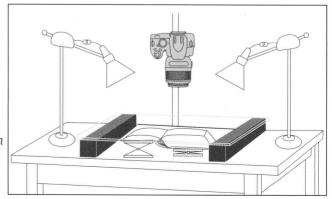

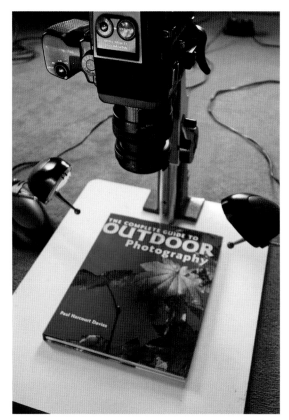

I could use a scanner to capture an image of this book, but the result would appear flat. Using a copy stand adds three-dimensionality to images that a scanner cannot.

of the camera can help, but be aware that this will necessitate an exposure increase because polarizing filters are tinted, and generally cut out about two stops of light.

Book Illustrations

Far too many rare books with hand-colored illustrations are ripped apart and the image pages sold separately as art prints. For anyone who has beautiful books long out of copyright, excellent reproductions can be made as digital images, which can then be printed on fine art papers.

Paintings

Large paintings and frescoes must be photographed as they hang. Museums often impose strict rules that don't allow visitors to take photographs. After all, many of them create revenue by selling prints, postcards, and books of the artworks, wanting you to buy these artifacts rather than take your own photos. If you do get permission to photograph pieces of art, beware of a couple of common challenges:

- Avoid reflections from glass or varnished surfaces. Light the painting from either side at an angle of 45° (or more) to the camera axis and make sure that the specular reflection due to light from windows does not escape your notice. You may need to hang a curtain or sheet over the windows, or choose a different time of day to shoot when the light coming in isn't so harsh.

- Align the camera so the center of the work is at the center of the camera viewfinder. Using a spirit level to make sure the camera is level; otherwise picture edges will appear to diverge or converge—though this can be corrected in post-production.

A camera on a copy stand gives me more control over the photograph than a scanner. That's why I use one to achieve the best possible image quality for rare stamps and banknotes. A sheet of carefully cleaned glass can be used to keep them flat. These stamp designs were taken from my photographs of wild orchids in Cyprus.

Can I make macro images with a scanner?

A flatbed scanner can be used to create high-resolution digital images of objects placed on its glass plate. In the case of essentially flat objects, like leaves or feathers, the process of creating an image isn't much different than making a photocopy: Simply place the object on the scanner plate, close the lid, and scan. For the background, you can use the reflective white sheet provided with the scanner or substitute this with matte-black flock paper, or any other color that you like. (You can also adjust the background in post-production by selecting and replacing it.)

To scan bulkier objects, you will need to leave the lid open (or remove it altogether if your scanner allows this). Scanners are capable of surprisingly good depth of field because the lenses used in the scanner head have a very small aperture, which is ideal for cumbersome subjects that have much of their surfaces up off of the scanner plate. With flat objects, there is little danger of light entering from the sides, but if the lid is raised at all, you will need to drape a black cloth over the scanner to prevent any outside light from entering the scanner and reducing the contrast of the scanned image.

Scanners tend to attract dust to their glass plates due to the electrostatic charge that can be

created by the scanning process. It pays to keep the glass scrupulously clean using a cleaning fluid that cuts that electrostatic charge. Less dust in your scanned images means less work to remove dust spots in post-production.

The resolution achievable will depend on your scanner. With an A4 (approximately 8.5 x 11 inches; 210 x 297 mm) or larger scanner plate set to 3200 ppi, the resulting image quality can be truly amazing. The scanner essentially acts like an enormous digital plate camera. In fact, some large-format digital cameras have backs that effectively scan the image. Scanners are not cameras, however, and can't be used for moving subjects.

First arrange your flat subject(s) on the flatbed glass. Here I draped black velour over a frame that I placed above the scanner. Later, in post-production, I selected all the objects, feathered the edges slightly, then inverted the selection and replaced the entire background with black.

Many scanners allow you to raise the lid on a hinge that permits you to get leaves on the flatbed without squashing them. You'll need to drape dark material over the scanner to exclude ambient light. You can also shift uniform background tones in your image-processing program, as I did here converting gray to white.

There are so many image-processing programs. What should I use?

It is very easy to become so enamored with an imaging program that you look forward to playing with all the bells and whistles. However, the most practical approach is to use a program as a complete work center, one with an intuitive interface that allows importing and cataloging of files, as well as adjusting and processing them in order to put them online, e-mail them, make prints, or even create slide shows.

Adobe Lightroom does all this and more, and it has revolutionized workflow for many. A large number of photographers find themselves using Photoshop, Elements, and other programs less and less for everyday work, though these applications come into their own for precise local correction and adjustment. Lightroom does the work of multiple programs, and is ideal for people working with RAW files, which must be processed before they can be printed or posted on the web.

Why go to the trouble of shooting RAW files? As discussed, RAW provides more control than other formats over the image during processing. Nevertheless, many photographers began their digital photography shooting JPEGs and TIFFs. Multiple files were created, resized, and cropped; then, over time, the originals got lost or altered. There is a much safer way to work because Lightroom allows you to process RAW files in a way that is nondestructive. All changes made to the RAW images are held in a sidecar file. This second file contains the changes you make as a set of instructions that can be exported or stored with the unchanged original. Any number of these sets of instructions can be made and stored in the catalog, without duplicating the original, so you don't have to find storage for a number of files, just the RAW file and the small sidecar (instruction) files.

The Lightroom workspace is simple and intelligent. It has a large central screen on which you can magnify an image to 100% (one screen pixel for each file pixel) or more to deal with individual details. That screen has side panels: On the left, you'll find the locations and names of various catalogs and collections; on the right are the controls. Below, you'll find a "film strip" of your images. The interface is easily customizable to suit the way you want to work.

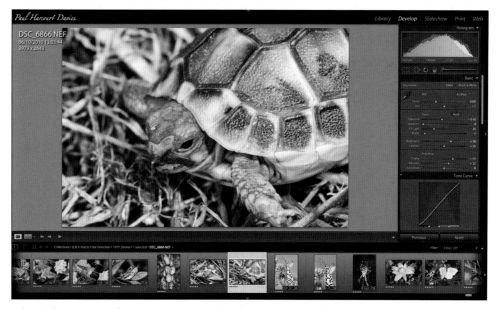

The Lightroom workspace puts you in the driver's seat with easy access to all the images in your library and the ability to arrange them quickly into collections with a keystroke or two. Switch from the Library to the Develop module to make your adjustments.

What is a digital workflow?

The series of steps involved in the post-production process of your image constitutes a digital workflow. It is important to establish a routine in order to minimize the amount of time you spend in front of a computer. Watching your pictures change as you process them might be an enjoyable novelty at first, but it can become hugely time-consuming when you have a lot of images to enhance. The broad steps of a basic workflow follow the organization found in Adobe Lightroom, which we'll continue to look at more closely in the following pages.

- **Import:** Get the files into the computer from your memory card, or into the program from your hard drive or other source.

- **Organize and store:** Transfer your image files to the appropriate place in a catalog or library where you can find them again.

- **Develop and adjust:** Work with the program's tools to make global adjustments and enhancements to your image files.

- **Export:** Export your images to a full-featured image-processing program such as Adobe Photoshop or Photoshop Elements to work in Layers and perform pixel-level enhancements .

Additionally, from within Lightroom, you can produce slideshows (with a simple fade transition fitted to a music track), prints (without frills or from a sophisticated print module with preset templates), and web galleries (via a range of templates designed for displaying sets of images online). Now, let's consider the preliminary steps of importing and storing your image files.

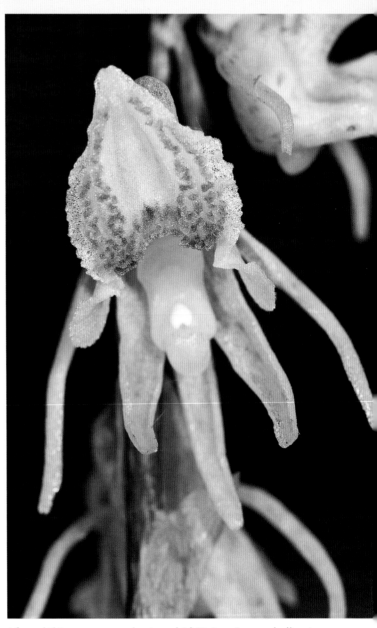

I found this very rare ghost orchid (Epipogium aphyllum) after several years of looking. It grows in gloomy beech-woods and only blooms sporadically. I wanted to make sure I got the most out of my RAW file, so I followed a workflow to catalog and enhance the image.

To start, image files can be imported directly from your camera or by downloading from your memory card via a card reader (which tends to be quicker). When it comes to organizing those images, you may understand that collections of images grow far more rapidly than we ever anticipate; chaos quickly ensues without some way of cataloging them. Few photographers will confess to enjoying the process of filing and organizing, but it helps to think of the way an office works, where items are placed in file folders, hung in drawers, and grouped in cabinets.

Lightroom's Library function keeps track of image files that are imported for enhancement. The digital data is stored on a hard drive and the files are labeled and tagged so they can be accessed and grouped in any way you choose. I suggest labeling files with keywords as they import so it is easy to find the type of photo you want.

The Lightroom program is structured in a series of seamlessly interlinked modules. After importing and storing the files, you can process them to make improvements. Users of Lightroom have the benefit of a comprehensive series of video teaching tutorials that take you through everything you need to know, and these are worth the time to watch before you start cataloging your images. There is also a vast online community with all sorts of plug-ins available.

The screen shows a variety of shots I took on a daylong field trip. I input the files to Lightroom and back them up on an external drive as soon as I can label them and add a basic set of keywords. If you ignore such steps, you will find it very time consuming to find the photo you want among your library of images.

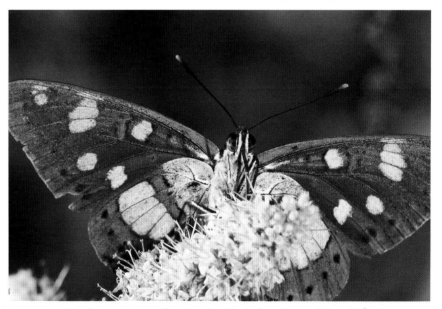

I can put this photo into a collection that includes other white admiral butterflies. Then I simply open that particular collection to see all the photos of this particular species of butterfly I've recorded over the years.

How should I process a RAW file in Lightroom?

Don't be confused by all the enhancement possibilities in Lightroom's Develop module. Not all adjustment sliders are equally important. What follows is an effective yet simple routine for developing RAW files. Remember, it doesn't matter if you misstep; the original file always remains unharmed. Just reset the process and start again.

The best results for your final photo depend on producing a solid black and a pure white in the image. This ensures good contrast, optimal color range of midtones, and the best print possible from the file. So, the first step is to set black points and white points using the sliders in the Basic control set. To do this, you have to read the histogram in the upper right of the module. Remember, the histogram is a pictorial representation of the pixel quantity at each luminance level (from 0 to 255—see page 28).

A histogram that stretches from the left axis to the right encompasses the full range of the tonal scale. Failing to use the full range produces dull images that lack contrast. Avoid spikes at either end since they reveal shadow or highlight clipping and lost detail information. The histogram illustration indicates if exposure needs to be reduced to avoid highlight clipping, or increased to retain shadow detail. You can preview the extent of clipping by clicking the triangles in the left and right upper corners of the histogram, which create masks on affected areas in the image.

Also, the overall tone of any image in Lightroom can be changed via the Color Temperature slider. Notice that as you move the zoom or hand tools over the image, the changing RGB values appear beneath the histogram. This is useful for locating pure white or neutral gray

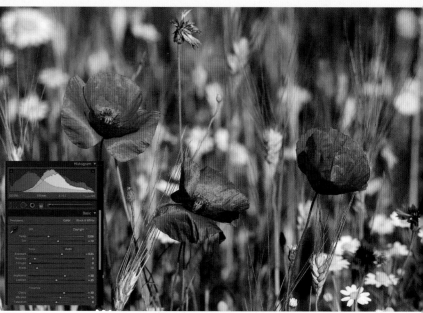

An important early phase of the processing routine is to set the black point (Blacks slider) and then the white point (Exposure slider) so that you have a full range of tones in your final image. This helps produce a photo that "pops" off the screen.

when, for example, you want to use the dropper tool to adjust color temperature.

The Basic Recipe

- **Set the black point.** Control this using the Black slider in the Basic box. Watch the histogram as you move the slider so the graph just touches the left axis, or keep an eye on the left clipping indicator (■), which converts from clear to a color as channels begin to clip, and to white as clipping begins for all channels. In addition, press the Alt (Windows) or Option (Mac OS) key as you grab the slider and the image screen will turn white. Now move the slider slowly and you will see dots of color and shapes that become black as clipping occurs. Release the key, look at the image, and see if it's what you want.

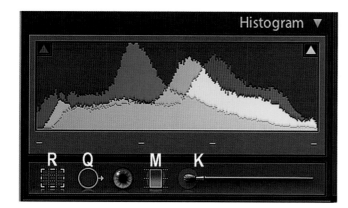

Just below the Histogram lie some very effective enhancement tools, four of which are accessible with a single key press: Crop Overlay (R), Spot Removal (Q), Red Eye Correction, Graduated Filter (M), and Adjustment Brush (K).

- **Set the white point.** Control this using the Exposure slider. Watch the right side of the histogram and the right clipping indicator (◣◢) to see when highlights begin to clip. Using the Alt/Option key turns the screen black, with clipping areas denoted by white areas.

- **Note tiny sparkles and reflections.** These will always be outside the ability of the sensor to capture. If you try to bring everything within the histogram, you can end up with a lifeless, dull result. Check to see that areas of white (or other light tones) contain detail and are not burned-out.

- **Fill light.** This slider will lighten backgrounds that are too dark. However, don't overuse this tool or you will dull the overall picture.

- **Clarity.** Use this to increase local contrast, which adds depth of color. It is best viewed at 100% or more.

- **Vibrance.** This minimizes clipping as colors approach saturation, and is quite effective in preventing skin tones from becoming oversaturated.

- **Saturation.** Move this to adjust saturation of all colors on a scale from −100 to +100 (monochrome to double saturation).

You can create presets to speed the enhancement process when doing batches of images. But you will generally need to deal only with these sliders for the majority of your RAW files, leaving additional fine-tuning for files you want to print or send to agencies.

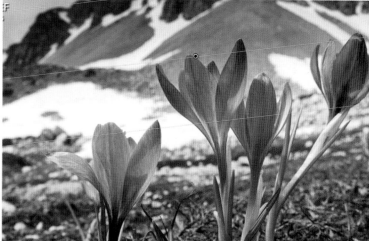

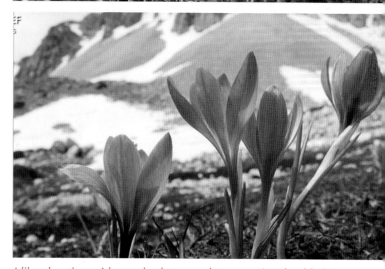

I like shooting wide-angle close-up photos against backlighting, a scenario that stretches the capability of any sensor to handle the dynamic range of the scene. The effect of using the Graduated Filter in Lightroom is obvious in the top shot above. Select the filter's tool, then click in the image and hold and drag downwards to create the filter. You can make further adjustments for exposure brightness, sharpness, and contrast within the selected area of the image.

What does Tone Curve do in Lightroom?

If you are primarily concerned with creating images and merely want to tweak them quickly in post-production, you might never venture past the tools in the Basic panel of the Develop module. However, there is a great deal more you can do in terms of image adjustment using this powerful program. One of the most useful panels for subtle adjustment is Tone Curve.

Use the Tone Curve tool to alter the tonal range of an image that you have worked on in the Basic panel. The horizontal scale represents the original tonal values of the image you have imported to the program (input), while the vertical scale shows how these values are changed by dragging up (making tones lighter) or down (making tones darker) on the curve (output values). The curve you see when you open the Tone Curve panel is the Lightroom default, which represents a slight contrast adjustment applied by the program at import. Black is found in the extreme left corner of the horizontal scale and at the lowest point of the vertical scale; white at opposite ends of each. A straight line at 45° that diagonally bisects the panel's window signifies no change from input to output values.

To work with the Tone Curve adjustment, grab the line of the curve and drag it, or move any of the four sliders below the panel's window.

The top image displays a straight diagonal in the Tone Curve box. By manipulating the tool into a classic "S" shape, I was able to increase the tonal range and contrast of these colonial algae (lower).

- **Highlights:** Moving the slider to the left will make the lightest tones (25%) in the file darker, perhaps showing detail that may have been slightly blown in the original; moving to the right will lighten these tones further.

- **Lights:** Moving the slider to the left will make light tones (25% below highlights) in the file darker; moving to the right will make them lighter.

- **Darks:** Moving the slider to the left will make tones darker, perhaps adding solidity to the image; moving to the right will lighten these dark tones, sometimes bringing out detail in some of the darker areas of an image.

- **Shadows:** Moving the slider to the left will make the darkest 25% of the picture's tones darker; moving to the right will lighten the shadow tones, again revealing hidden details in the darkest range of tones as long as the original image recorded data in those deep shadows.

When using these sliders, you are making rather broad tonal adjustments. To explore Tone Curve even further, try using the presets that can be found in the Point Curve menu at the bottom of the Tone Curve panel. They are:

- **Linear contrast:** This sets the curve to a perfectly straight diagonal in the panel window and is useful to flatten images that have a great deal of contrast, making them more flattering.

- **Medium contrast:** Dark tones are brought below the linear curve and bright tones are raised slightly. This works well for close-up shots of natural subjects.

- **Strong contrast:** This exaggerates the effect of medium contrast images, but is good for very low contrast images.

You can also adjust tones by dragging within the image itself—just click the small bull's-eye to the top left of the curve graph, and then click on an area in the image that represents the tones you want to adjust. Now, if you drag the mouse, it will adjust the curve for all tones in the image that are the same as the one you clicked. Click the bull's-eye again to de-activate this function.

In addition to adjusting tones, particular colors can be boosted or altered via the HSL (Hue, Saturation, Luminance) sliders.

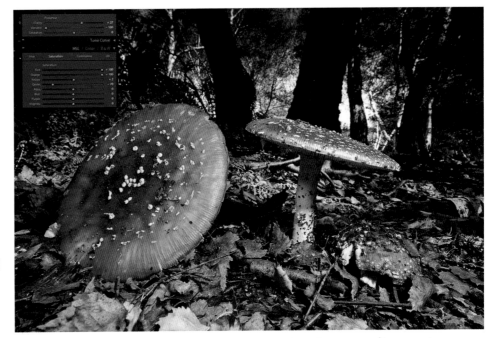

I wanted to reproduce the same vibrant red color of this fungus in Lightroom that I saw in the wild, so I used Saturation in the HSL panel to boost red and orange, and remove green. I also reduced Vibrance in the Presence panel to zero. The result mixes intense color and monochrome, emphasizing the sinister aspect of this highly toxic fungus.

- **Hue:** This control changes colors completely.

- **Saturation:** This modifies how vivid a color is. For example, a green leaf can be changed from a dull brown, devoid of green tones, to an intense, forest green.

- **Luminance:** This controls the brightness of a particular color range, so the color can look very deep (dark) or nearly washed out (bright).

- **B&W:** This set of sliders converts a color image to black and white. It operates like a subtly variable set of black-and-white filters on your camera's lens, permitting the full tonal range of a monochrome photo.

- **Split Toning:** This tool can reproduce color tones associated with older photographic processes, such as sepia (sulphide toning), platinum, selenium, or a host of others.

What are the best settings for sharpening and noise reduction?

Sharpening and noise reduction tools are found within Lightroom's Detail panel. Most photographers who use DSLRs see the need to sharpen their photos to offset the softening that their camera's anti-aliasing filter produces to prevent Moiré patterns. In other programs, sharpening is applied as the last step—if it is carried out too early, subsequent adjustments can affect the appearance of sharpness in the image. However, since Lightroom is non-destructive, nothing is changed irrevocably whenever you sharpen, and you can readjust if needed.

Sharpening: This adjustment is subjective, and many photographers are heavy-handed with it, which can result in harsh-looking images. It is not as easy to oversharpen using Lightroom as it is with Photoshop.

There are four sliders that control different aspects of the sharpening algorithms. When using them, zoom in on an image to 100% or more so you can see the effect.

- **Amount:** This adjusts the edge definition to raise the overall sharpening level. Zero produces no sharpening, and lower levels yield cleaner images with fewer artifacts than higher settings.

- **Radius:** This adjusts the size of details to which sharpening is applied. Very small details are preserved with lower levels, while high radius levels can produce images with poor quality.

- **Detail:** This slider adjusts how the sharpening algorithm accentuates edges in the image. Higher values emphasize texture, while lower values sharpen edges to remove blurring.

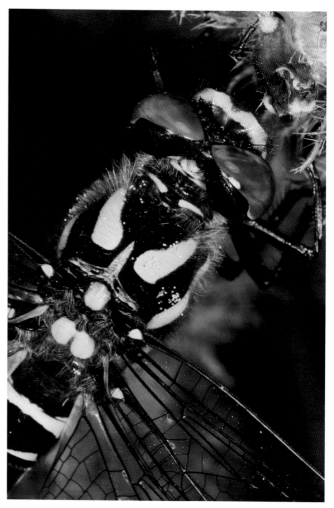

There is a lot of fine detail in the wings and hairs of this golden-ringed dragonfly (Cordulagaster boltonii), and the Lightroom sharpening algorithms work well to help define them.

- **Masking:** This controls where sharpening will or will not be applied. At the zero setting, the same amount of sharpening is applied in all areas of the image. As you increase the value toward 100, sharpening becomes more and more restricted to the strongest defined edges.

Noise Reduction: Noise refers to artifacts that appear in digital images, usually as multi-colored specks in dark areas or in areas of continuous tone, like a sky. Small sensors, long exposures, and high ISO settings on the camera are the most common causes. The noise filters in Lightroom are as effective as some dedicated noise reduction packages.

There are two groups of parameters in the Noise Reduction panel that you can adjust: Luminance and Color. Both of them reduce detail (making the image look a bit blurred), so you need a careful balance between Noise Reduction and Sharpness.

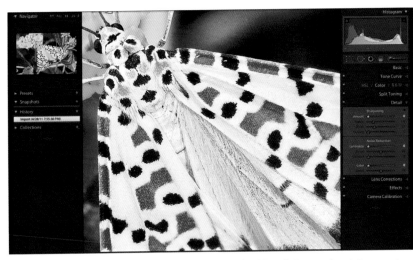

Sharpening is a great tool, but should be used with a light touch—it is easy to overdo it. It is a good practice to look at selected portions zoomed to 100% so you can see the effects of moving the Amount and other sliders. You can also compare what the image looks like before and after applying sharpening.

- **Luminance:** This adjustment deals with grain that may appear in your images. It is best to set the slider below 30 as a matter of preserving sharpness. Below the Luminance slider lie associated Detail and Contrast sliders used for particularly noisy images. With Detail, the lower values give cleaner results but reduced detail; higher values preserve detail but produce noisier results. With Contrast, lower values give smoother results but lower contrast; higher values preserve contrast, but blotches appear.

- **Color:** This slider handles those random speckles of color in dark areas. This adjustment is often unnecessary if you don't see the speckling in dark areas of the photo. If it is needed, keep the setting below 10—again, to preserve sharpness. There is a Detail slider here, too—the higher values protect detail in colored edges, but produce speckling; lower values deal with the speckling, but edge coloring can break up and become softer looking.

Noise in an image (upper) can be reduced with the Noise Reduction sliders, but often at the expense of overall image sharpness (lower).

What else can I do with the Lightroom modules?

Lightroom includes a Slideshow module that allows you to produce functional, good looking shows quickly, though it is not as flexible or as fully featured as slideshow programs like Keynote (Mac) or Photomagico for professional presenters. In Lightroom, you simply create a collection within the program and then switch to the Slideshow module. There are limited transition options, but the slides can be easily re-ordered with a simple drag-and-drop using the filmstrip view below the main screen.

Slideshows are an excellent tool for showing work quickly to clients or as an instructional tool. For example, I often teach groups of students about photography. After their photos have been recorded throughout the day, I can make photo selections, organize them quickly, and show the results for all

to see from the slideshow. The timeliness makes the exercise relevant to the workshop participants as the images are used to illustrate points made during the day. This immediacy is appealing and useful.

You can also print your image files from Lightroom, but the range of layout templates plus a versatile custom facility in the Print module allow you to do more than make single photo prints. You can produce a conventional art print, a triptych, or some other layout such as a contact sheet. You can create borders, a nameplate to add to cards, and produce a range of

I find the Slideshow module an extremely useful tool in my business, allowing me to show clients where I can take them on photo expeditions and to follow-up immediately in a visual way with school kids after a photographic day trip.

high-quality promotional material. You can bring an image into the Print module as a JPEG file and save it there, choosing to either print it on your own desktop printer or send it to a commercial printer (particularly smart when bulk printing is needed, or if you like to use black borders, which notoriously use up ink).

For blogs, the Print module offers a way of producing something much more interesting than an image merely for insertion into your article. It is especially convenient for grouping photos and creating layouts with images from your catalogs and collections (there are numerous examples in my blog posts on the Pixiq website).

Since Lightroom functions seamlessly with Photoshop, you can use the latter to enhance photos and designs after exporting from Lightroom. There, some of the alterations, adjustments, and products include:

- **Borders:** The border of any color can be created to surround the image. Open the image in Photoshop, select Image > Canvas size.

- **Layers for adding text:** Create layers to add viewable titles and/or captions on top of your image files. Flatten the image and export at the image size you require for use in a blog or other purposes.

- **A business card:** Design a business card (with a close-up of a bug or flower to show your shooting skills) in any image-processing program and import the file into a Lightroom layout. You can do the same for CD/DVD covers and so on. The register is perfect and automatic.

- **Books:** Creating books in the latest version of Lightroom is limited only by your imagination. I create individual pages, and then use the Print Job > JPEG File command, before printing a file. The

Paul Harcourt Davies

You have many options for creating beautiful prints suitable for framing in your home or for producing promotional flyers and brochures about your art.

JPEG obtained is imported into iWorks Pages where text pages can be added, though any layout design program would do.

The Adobe website contains a thorough and downloadable manual. Internet information abounds with tips and advice on all the Lightroom tools. Media include PDFs, websites, and numerous videos and webcasts offered by established image-processing gurus.

DEPTH of FIELD TABLE* in Millimeters (mm)

Reproduction Ration	Magnification (M)	f/5.6	f/8	f/11	f/16	f/22	f/32	Exposure change in stops (M+1)
1:10	0.10	41	59	81	118	162	235	1.1
1:8	0.12	27	38.5	53	77	106	154	1.12
1:6	0.17	15.7	22.5	31	45	62	90	1.17
1:5	0.20	11.2	16	22	32	44	64	1.2
1:4	0.25	7.5	10.6	14.6	21.3	29.2	43	1.25
1:3	0.33	4.5	7.2	8.8	14.4	17.6	29	1.33
1:2.5	0.40	3.24	4.6	6.38	9.28	12.8	18.6	1.4
1:2	0.50	2.25	3.2	4.4	6.4	8.8	12.8	1.5
1:1.7	0.58	1.74	2.48	3.41	4.96	6.82	9.92	1.58
1:1.4	0.71	1.3	1.84	2.53	3.68	5.06	7.28	1.71
1:1	1.00	0.75	1.07	1.47	2.14	2.93	4.27	2
2:1	2.00	0.28	0.4	0.55	0.8	1.1	1.6	3
3:1	3.00	0.16	0.24	0.32	0.47	0.65	0.95	4
4:1	4.00	0.11	0.17	0.23	0.34	0.46	0.68	5
5:1	5.00	0.09	0.13	0.18	0.25	0.36	0.51	6

* Based on a circle of confusion of 1/30 mm

This table lists depth of field (front to back) in millimeters at certain magnifications and aperture settings. For example, at M = 2x, the depth of field at f/11 is 0.55 mm.

This is useful when creating image stacks where the distance moved between successive shots must be less than the depth of field.

Doubling f/number (e.g. f/8 to f/16; f/11 to f/22; etc.) increases depth of field by factor of 2.

Closing down diaphragm by 1 stop (e.g. f/5.6 to f/8; f/11 to f/16; etc.) increases depth of field by factor of 1.4.

The last column (M+1) is used to find the Effective Aperture Effective Aperture = (M+1) x F, where F is the aperture number set on the lens.

For example, Effective Aperture at life size (M = 1x or 1:1), with lens set at f/8, is (1 +1) x 8 = 2 x 8 = f/16.

At 3x magnification with an aperture set at f/5.6, Effective Aperture = (3+1) x 5.6 = 22.4 (or f/22, closest marked f/stop).

As a general rule the Effective Aperture should not exceed f/32, and preferably be lower than f/22 to avoid diffraction softening.

Use this data to work backwards making sure you do not set too small an aperture on the lens.

For example, at 4x magnification, the change in stops is 4+1 = 5. So f/4 on the lens = 5 x 4 = f/20.

Similarly, f/8 becomes 5 x 8 = f/40; and f/5.6 would be 5 x 5.6 = f/28.

Exposure Factor: In most cases, flash is the most effective form of lighting. Set the camera on Manual exposure mode and let the camera's DTTL system take care of exposure. When using other lighting (e.g. incandescent lamps or fiber optics), exposure times should be increased by a factor of $(M + 1)^2$.

INDEX

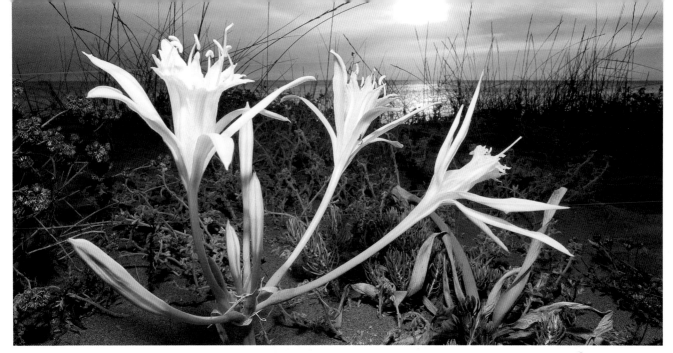

Lighting for these sea daffodils (Pancratium maritimum) was a mix of foreground flash from a diffused hand-held accessory unit and natural light (sunset) in the background. This is the kind of scene that is perfect for the experimentation that digital photography allows. The camera was set on Manual exposure mode to meter the background, and several different exposures were applied to the foreground by using the compensation buttons on the TTL flash control unit.

between foreground and background light when framing wide-angle compositions, because the background proportion of a scene is quite large at close quarters. With bright skies, this could lead to exposure problems.

When using artificial lighting in these situations, you will have to balance background illumination with flash on the subject. Be careful when placing lighting units to the sides of the scene when using wide-angle and diagonal fisheye lenses to avoid having them appear in the frame. Macro flash or ring flash units are useful for this type of setup.

A translucent piece of acrylic works effectively with wide-angle and ultra-wide-angle lenses to light close-up subjects without casting shadows. Place your lens through a hole cut in the sheet. Any flash can be held behind the panel so it casts light through it.

What are some different techniques for lighting close-up scenes?

Through the lens (TTL) flash control was born when normal TTL metering could not be used for flash because the photodiode that registered the light was obscured as the SLR's mirror was raised to make an exposure. The ingenious solution was to measure light reflected from the film's surface during exposure and to quench the flash when sufficient light had hit the subject.

However, this solution did not work with digital cameras because sensors do not reflect light in the same way as film. Digital TTL (DTTL) flash involves a different system: a pre-flash is fired, the exposure is analyzed, and the main flash then follows within fractions of a second.

Close-up flash photography in the field before TTL was always a matter of trial and error. With DTTL, there is much less guesswork or fiddling with handheld meters—you can stalk small creatures and bright flowers in the field secure in the knowledge that you will record well-exposed shots using your flash.

Let's look at some techniques that provide variety for lighting close-up scenes:

Backlighting: This can come from either natural light or a single off-camera flash unit behind and to the side of a subject. It creates a rim light that accentuates hairs on flower stems or on insects. This little bit of magic can elevate the quality of your pictures to a new level, and can be accomplished most easily with a radio-controlled system. A manual flash system with a

photoelectric trigger works well too, just avoid placing the flash along the lens axis or too close to the subject.

Dark field: This dramatic form of lighting, borrowed from microscopy, is backlighting against a black background. Put a piece of black cardstock, flock paper, or foam board behind the subject and place a light source behind and to the side so the light comes in from a 45° angle.

Include natural backgrounds: Backgrounds often go dark when using close-up flash because the intensity diminishes as the light moves away from its source. The problem can be avoided by making sure that some background leaves, stones, or portion of the ground are close enough to be illuminated along with the subject.

Natural light is utilized for backlighting by carefully positioning your camera. In this photo of poppy buds (Papaver rhoeas), the background was dark, yet the low angle of a late afternoon sun backlit the plant hairs. A single diffused flash gave some light to the foreground.